CHELMSFORD

THROUGH TIME

Jim Reeve

AMBERLEY PUBLISHING

First published 2013

Amberley Publishing
The Hill, Stroud, Gloucestershire, GL5 4EP
www.amberley-books.com

Copyright © Jim Reeve, 2013

The right of Jim Reeve to be identified as the
Author of this work has been asserted in accordance with
the Copyrights, Designs and Patents Act 1988.

ISBN 978 1 4456 0869 3

British Library Cataloguing in Publication Data.
A catalogue record for this book is available from the
British Library.

Typesetting by Amberley Publishing.
Printed in Great Britain.

Introduction

The three rivers that flow into Chelmsford have had a great influence on its growth, and have made it the city it is today. The River Chelmer rises in the north-west of Essex at Wimbush. The Can gets its name from Great Canfield where it starts as just a trickle. There were people living by the river near the town around the year 2000 BC. Proof of that is the Neolithic cursus and burial mounds that have been found at Springfield and now lie under the Asda car park. Around 900 BC, during the late Bronze Age, Chelmsford had a sword factory, and evidence of roundhouses has been found under the site of the Parkway car park. There is no evidence of the Romans settling in Chelmsford after Claudius invaded Britain, but their armies must have passed through the town on their way to Colchester. It was the defeat of Boudicca (also spelt as Boudicea) in AD 60/61 that brought about a military post on the road from London to Colchester. The Romans named the post Caesaromagus, which means Caesar's Field. Chelmsford has the honour of being the only city that bore the great man's name.

Soon, the fort expanded and, to give the troops some measure of comfort, baths, and then, by the second century, houses and commercial premises were added. The town became a market, where citizens could sell their goods and services.

When the Vandals sacked Rome in AD 410, the Roman troops were withdrawn and Chelmsford, like most cities in Britain, was plunged into the Dark Ages. The Romans had built a bridge over the Can, which, in the absence of maintenance, collapsed. Luckily, there was a ford that was controlled by a Saxon named Ceolmaer, who gave his name to Chelmsford, while Moulsham took its name from another Saxon name, the Muls Ham – the home of Mul.

By the time the Normans invaded in 1066, there was a settlement to the north of the present town centre. The population of peasants were tied to the land for life. In the Domesday Book of 1086, the Manor of Chelmsford was described as a 'small rural farm' that had only four households, whereas Moulsham had twelve. Edward the Confessor (1042–1066) gave Chelmsford to the bishops and it became known as Bishops Hall. It remained in their hands until Bishop Bonner gave it to Henry VIII.

In the twelfth century a bridge was built over the Can, following the Roman Road. Chelmsford, as a town, came into existence during the reign of the notorious King John, who granted William of Sainte-Mère-Église, the Bishop of London, the right to hold a market once a week in the High Street. Travellers to Colchester from London had to pass through Chelmsford and shops sprang up along the side of the market to serve this trade.

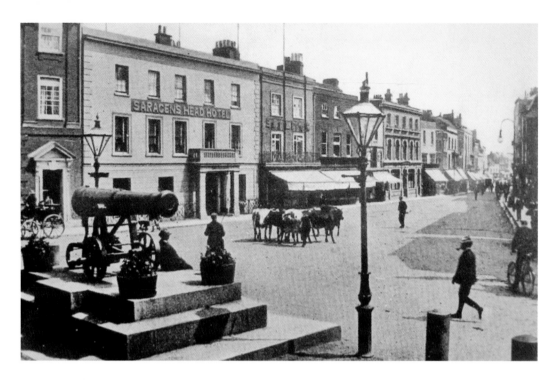

High Street, 1900 and 2013

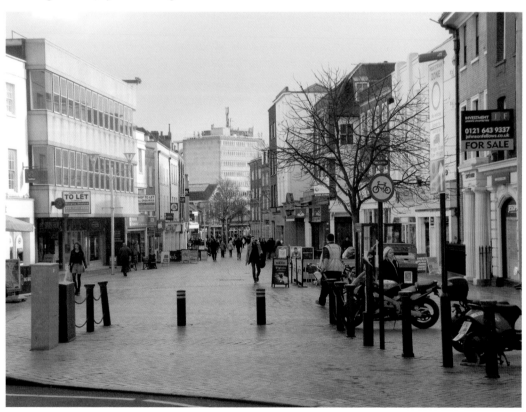

Chelmsford High Street

In 1199, King John granted a charter to Chelmsford to hold a market. A year later a further one was given to the Bishop of London, William of Sainte-Mère-Église, to grant plots around what is now Shire Hall and down to the river. The stalls that were nearer the river were less expensive because they were smaller. Those at the top end measured nearly 600 feet long. In 1201, he was granted rights to hold an annual fair on 1 May and for three days after. The offer was taken up by many people outside the Chelmsford area as the market looked as if it could be financially rewarding. The fees were due annually and tenants had to swear loyalty to the Bishop.

Moulsham did not have a market and as a result became the poor relation. Soon, buildings began to spring up along the High Street in place of the stalls and by the beginning of the fifteenth century, the area had all types of buildings, most of them with thatched roofs. A public water supply was set up from Burgess Well, which rose from the back of what is now the Civic Centre. The water was conveyed above ground to Duke Street; from there it was channelled underground, emerging by the Cross, and thence in an open channel down the middle of the High Street into the river. At the end of market day, all the rubbish was swept into the channel. It is understood that pigs were also let loose at this time to eat any waste. One can imagine the mess and it is not surprising that the rivers became foul. Animals were driven down the High Street as late as the 1940s. The market traded in everything from clothes, fresh fish brought from the coast, bread straight from the ovens, and live cattle and sheep. It is difficult to imagine, in these hygienic days, the smell that must have pervaded the air.

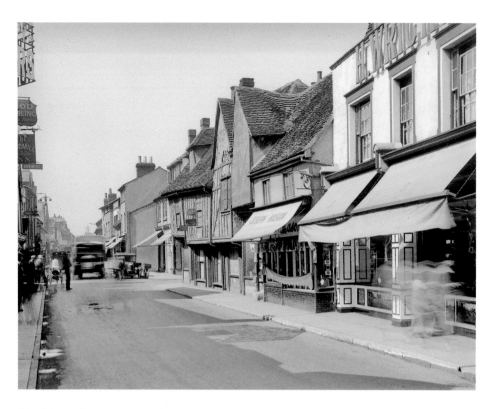

Moulsham Street, 1920 and 2013

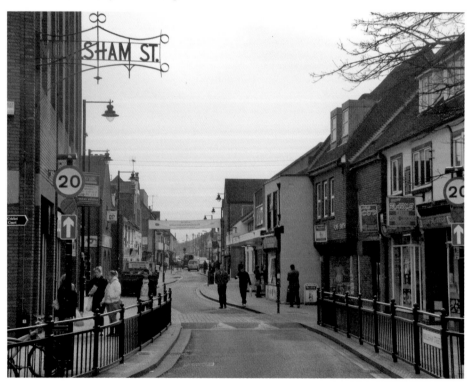

Moulsham Street

The Moulsham area of the city is thought to be the oldest. During excavations, ceramics of the Neolithic period (4000 BC) have been found, which is proof that man settled in the vicinity. Further evidence of settlements has been discovered, stretching back through the Bronze, Iron, and Roman Ages. A Roman fort and bridge were constructed on the southern side of the River Can and historians think that the present Moulsham Street goes back to Roman times, following the same line south towards London. Around AD 1100, the Roman bridge collapsed and it was necessary to build a new one.

After the Norman Conquest, it is recorded in the Domesday Book (1086) that the Abbot of Westminster owned Moulsham Manor while the Bishop of London owned the rest of the town. Over the years, the Moulsham area became the poor relation and tended to house the destitute of society. At one time it had a leper colony, a gaol and a workhouse.

Chelmsford did not escape the numerous outbreaks of the Bubonic Plague and in 1349 there was another one. It is recorded that in Moulsham alone over thirty families died. The 1665 outbreak was worse and a quarter of the population died. The disease was spread by fleas from the black rat and after being bitten, a person began to swell in the armpits and groin, which oozed pus and blood. Few patients survived, most died within four days. John Spight, a map maker in Moulsham Street, was the first to contract the disease. The authorities decided that as the plague had started in Moulsham they would protect the rest of Chelmsford by putting an armed guard on the Stone Bridge, thereby cutting the area off completely. John Green was paid to mark the doors of the victims, board up their houses, nurse them and bury them when they died.

For thirty-four days he stopped the disease spreading to the rest of the town, but finally it attacked the rest of the population. Twenty-five per cent of them died. At night, the dreaded call rang out, 'Bring out your dead!' and families would pile their loved ones on to carts, which took them off to a mass grave in a field near the river.

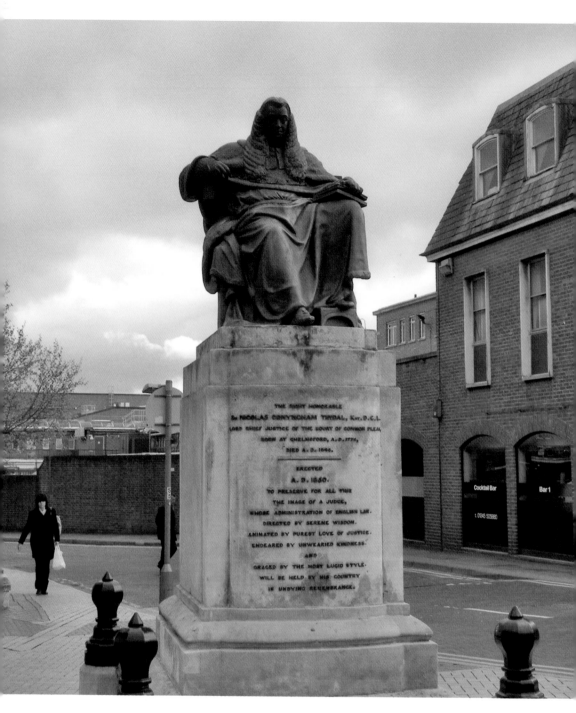

Statue in Market Street of the Famous Judge Tindal

Judge Tindal

The dignified statue of Judge Tindal stands opposite Shire Hall, which was once the Assizes. He is famous for changing certain aspects of the law. He was born in 1776 in a building that was where 199 Moulsham Street is today. He was educated at King Edward VI Grammar School in Chelmsford and then went on to Trinity College Cambridge. He came to prominence when he defended Queen Caroline of Brunswick (George IV's wife) when she was on trial for adultery in 1820. The Queen was very popular and during the trial there were riots. The King alleged that the Queen had a relationship with an Italian, Bartolomeo, but, after skilful argument by Tidal, the case was thrown out.

He changed the law by introducing 'not guilty by reason of insanity' in the case of Daniel M'Naghten *v*. Rex. Daniel had assassinated Sir Robert Peel's secretary, but was clearly insane and would have been hanged but for Tindal's judgement. Queen Victoria and the public were incensed by the verdict and called for Tindal's resignation.

In 1817, he was involved in the unique case of Ashford *v*. Thornton. Thornton was found guilty of the murder of a Mrs Ashford. He appealed, and Tidal found an obscure law whereby the defendant could challenge the brother of the dead woman to a battle. The brother declined and Thornton won his appeal. The ancient law was soon revoked by Parliament.

He changed the law in the case of Regina *v*. Hale. Tidal ruled that Hale was provoked to such a degree that any reasonable man would lose control and kill the person responsible for the provocation. He found Hale guilty of manslaughter but not murder.

In 1824, Judge Tindal became Tory MP for Wigtown in Scotland and then for two years in Harwich. He later became the Solicitor General.

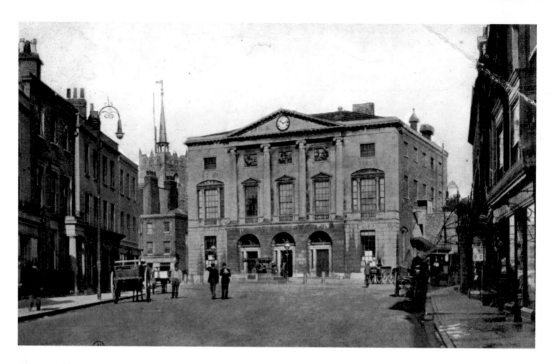

Shire Hall, 1900s, and Undergoing Restoration in 2013

Shire Hall

Shire Hall stands on the site of an older building built in 1569. It served as a court and was named Tudor Market Cross or sometimes Great Cross, and was also a market place. The ground floor was open to the elements and had galleries above which were enclosed. One can imagine the noise, hustle and bustle on a Friday when corn merchants sold their wares, while outside cattle, sheep and pigs were auctioned.

It was in Great Cross during the late sixteenth century and the early seventeenth that infamous witch trials took place. They were initiated by the Witchfinder General, Matthew Hopkins. During his time, he was responsible for the death of 230 'witches'. Three of them – Agnes Waterhouse, her daughter Joan, and Elizabeth Francis – were finally hanged on the spurious evidence of a twelve-year-old child. The women were accused of having a cat called Satan who helped them carry out spells. The animal was described as having an ape's head, horns and a silver whistle round its neck. It was said that the cat had caused the death of a man and his cattle. They were also accused of spoiling butter and cheese. In 1611, the Courts of Quarter Sessions fixed the wages for servants in Waltham Abbey at £3.00 per annum for a man servant and £2.50 for a maid.

In 1789, the original building was condemned because it had outgrown its useful life, and Shire Hall was constructed under the direction of the County Surveyor, Mr Johnson. The new building took two years to build, cost £14,000 and was financed by the local ratepayers. While it was being built the court continued, and in May and November the annual fairs were held. The builders hired a field in Duke Street to store their construction materials. Three figures were carved on the outside of the façade, representing Mercy, Wisdom and Justice. The road in front of the building was dirt, which had to be flattened regularly with a roller. During the winter the road became a quagmire and in summer a dust bowl.

In 1854, soon after the battle of Sevastopol, a cannon was brought back from the Crimea and set up in front of the hall. Some local youths could not resist firing the cannon; luckily they did not have a cannonball or the Saracens Head public house might not be there today. The cannon now stands proudly in Oaklands Park.

During the eighteenth and nineteenth centuries, the horse was the king of transport and the RSPCA installed a horse trough in front of the hall where it remained for many years. Until recently the building was used for wedding receptions and functions, but pieces of masonry started falling off and it was shut down. Its future is undecided.

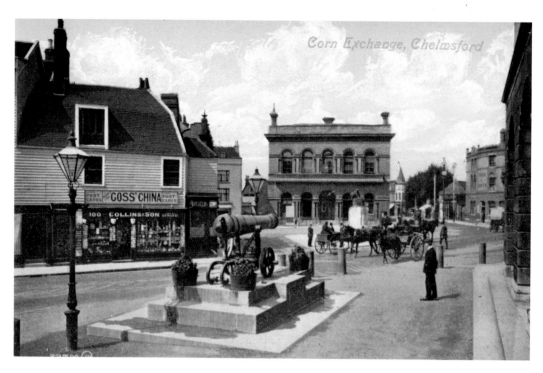

Corn Exchange

Pictured above during the late nineteenth century. The photograph below shows the approximate site of the Exchange in 2013.

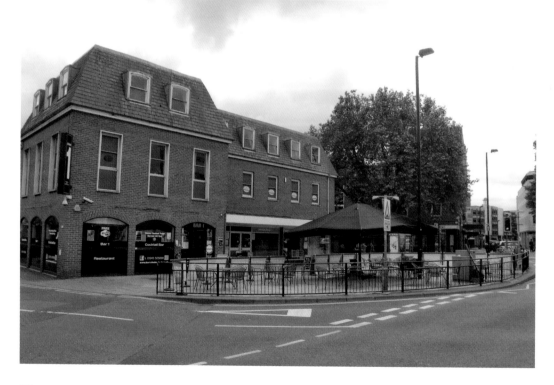

The Corn Exchange

The Corn Exchange in Tidal Square served the community of Chelmsford for many years and in many ways. It was designed on the drawing board of Frederic Chancellor and was opened in 1857. Previously, a space beneath Shire Hall had been assigned for the purpose of buying and selling corn, but was thought to be unsuitable as it did not let in enough light to enable the buyers to examine the corn for mould.

The new Exchange measured 100 feet by 45 feet and the roof of the main hall had an apex of 40 feet. The hall was curved at one end for a platform and at the opposite end it had a gallery, which allowed for public entertainments. Auctions were carried out in a large room and there were a number of offices.

One of the notorious politicians of the 1930s, Sir Oswald Mosley, held a meeting in the Exchange on 18 May 1935. Mosley was leader of the British Fascist Party and was invited by Chelmsford's Constituency Fascist Association to speak. As Sir Oswald Mosley stepped on the platform, the young Black Shirts rose as one and gave the Fascist salute. For two hours, he explained the aims of his party and answered questions. The meeting was well attended and it is not surprising there was no heckling, in view of the large band of young men and women in black shirts who kept order.

As Chelmsford developed and there was no longer a need for marketing corn, the Exchange was hired out for dances and dog shows and many musical groups played there. The owners finally became bankrupt and the Exchange was sold to the council. Sadly, they demolished it in 1969 to make way for the town's new development.

Barrack Square

14

Barrack Square

I was unable to obtain an old photograph of Barrack Square but felt I should include it because of its fascinating history. With the unrest on the Continent in 1789, and the later fears of an invasion by Napoleon, between April 1793 and 1794 over 8,400 troops were billeted in Chelmsford, outnumbering the population. The 1801 Census revealed that there were only 4,000 citizens living in Chelmsford at that time. Most of the troops were marching through the town to Harwich, but overnight they had to be billeted and every inn, barn, church hall and stable was occupied. During this time, crime rose sharply, which was put down to the numbers of troops passing through the town. If the offenders were caught they were subjected to as many as 100 strokes of the lash. If the soldier fainted, punishment was suspended until his back had healed and then the punishment was continued, often tearing the skin off his back, and sometimes exposing the backbone. Many soldiers died under the whip.

To add to this army of soldiers from the rest of the country there were the Loyal Chelmsford Volunteers and the Roxwell Volunteers. They had been raised for the defence of Chelmsford in case Napoleon invaded and under the supervision of the Royal Engineers built earthworks and gun emplacements to defend the town. They built two forts on a ridge to the south of Moulsham and one on Galleywood Racecourse, blocking the Maldon Road and thereby protecting one of the ways into London. There was another on the Clacton Road at Widford.

One of the restrictions in the will of Lady Mildmay's Aunt was that Lady Mildmay should live in Moulsham Hall for at least three months of the year. She was not very pleased when she discovered soldiers building the earthworks near her home and found it impossible to live in the house so she let it to the army. In 1813 the earthworks were decommissioned and destroyed when railway lines started to spread across the countryside.

In October 1804 a Hanoverian regiment were passing through Chelmsford on its way to Harwich and was billeted in the Spotted Dog. As the inn was full, many of the troops had to sleep in the stables. During the night, it is thought that one of the soldiers, not thinking, knocked his pipe out and the ash set the stables alight. Because the troops were foreign they could not work out how the locks worked and none understood their cries for help. Thirteen of them were burnt to death.

When the old gaol on the Moulsham side of the Stone Bridge was pulled down a barracks was built to accommodate troops of the West Essex Military and the 44th East Essex Regiment. All evidence of the barracks has now disappeared and the site is occupied by a Thomas Cook travel agency on one side and on the other, Toni & Guy.

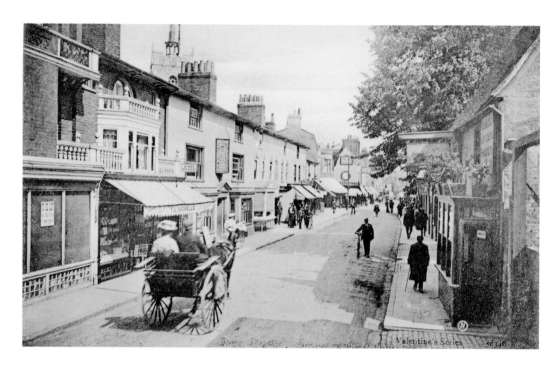

Duke Street, 1900 and 2013

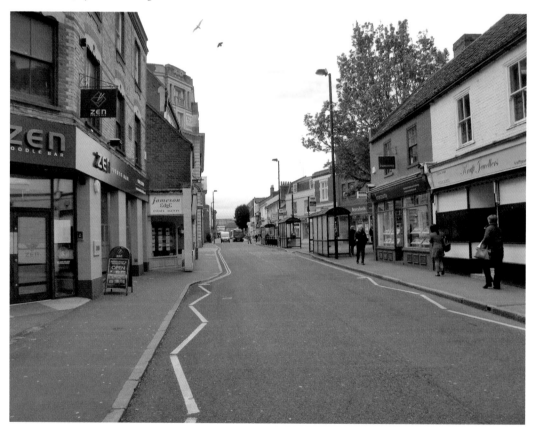

Duke Street

Over the years, Duke Street has had a number of names: Brochelestrate, Church Street, Duk or Duck Street. In 1361, Margaret Duk inherited the Springfield Manor and the street was part of it. By 1437, the street had six shops. Guy Duke owned a field on the west side, on the way to Braintree. Ironically, Duck Street was also an alternative name for New Street. In 1380, Nos 85–91 Duke Street belonged to John Scolemayster, who set up a school. Later in the 1390s the owner started brewing and selling ale.

In 1491, The Blue Boar Public House opened on the site of No. 84 Duke Street, and on the site of No. 79 Duke Street, The Chequers Public House was built. This was later changed to The George. It would appear that the reason for the number of inns and alehouses was the market, which was on the main thoroughfare from the town centre to the railway station. It used to have butchers, bookmakers, medical practitioners and confectioners.

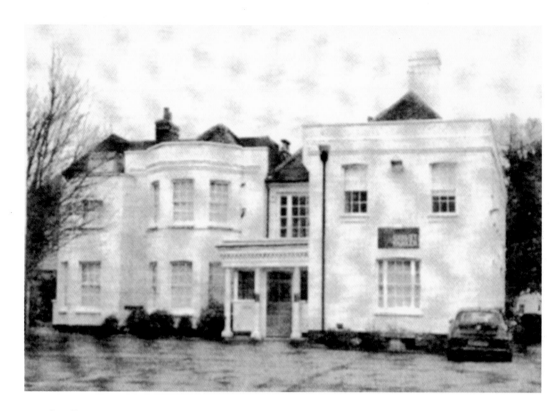

Coval Hall

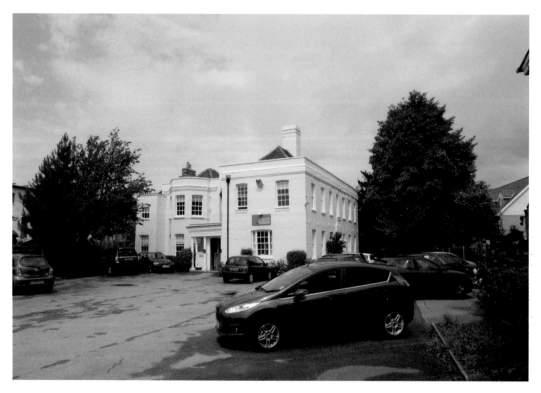

Coval Hall

It is recorded that in 1701 the Marriage family, who were millers and Quakers, lived in Coval Hall. Samuel and William Marriage were appointed trustees to the new Quaker Chelmsford Meeting House. It is also recorded that Charlotte Marriage, a prominent Quaker, lived in the house. During the middle of the eighteenth century, the hall was acquired by Richard Tindal, who was a captain in the Navy. The Tindal family were prominent during the eighteenth century, with most of the descendants doing well. John Tindal became a rector in Chelmsford and James pursued an Army career, while one of his sons became Chaplain of the Tower of London and would later unfortunately commit suicide.

The most prominent member of the family was Judge Tindal, who famously defended Queen Caroline of Brunswick, charged by her husband George IV of treason for committing adultery with an Italian, Bartolomeo. Judge Tidal had the case dismissed. He managed to have the ancient law of trial by battle removed from the statue book, when he defended Abraham Thornton for the murder of Mary Ashford. Thornton challenged the accuser to fight but he refused and the case was again dismissed.

It is understood that the hall remained in the hands of the Tindal family for three generations. Today it is the head office of Strutt and Parker, an estate agency who were established in 1885 by two friends, Edward Strutt and Charles Parker, to provide an estate management service for the local community. It has today grown into one of the largest property partnerships in the UK.

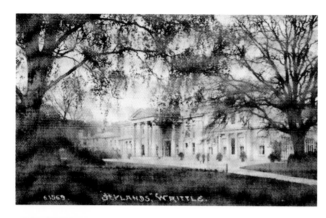

Hylands House, 1900 and 2013
(*Copyright Hylands House*)

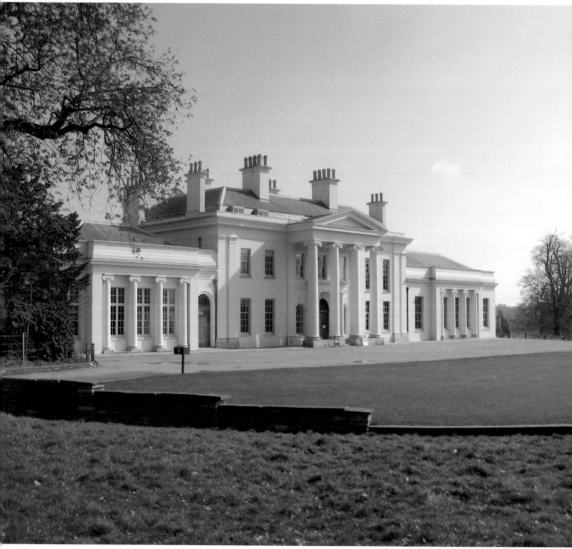

Hylands House

Hylands House was built in 1770 in the Queen Anne style by Sir John Comyns, who was once Chief Baron of the Exchequer and MP for Maldon. The house has had an interesting and chequered history. Sir John wanted it as a family home, but unfortunately he had no children and so, when he died, he left it and the grounds to his nephew, John Richard Comyns. In 1797, the estate was put up for auction and sold to a Mrs Kortright for a sum in excess of £14,000. The same year the grounds were landscaped by Humphrey Repton and it was around this time that the East Wing was added.

From 1803 to 1813, the threat of invasion by Napoleon hung in the air, and it was thought that he might land at Harwich and march on London. Troops from all over the country flooded into Chelmsford. The country was in panic, and gun emplacements and earthworks were thrown up. Hylands did not escape the military works and ramparts were erected in the grounds.

When Caesar Labourchere bought the house from Kortright, he did not realise that the railway was going to be built so close and be invaded by hundreds of navvies who descended on the area to lay the tracks. It irritated him so much that it became an obsession. He sued the railway company and nearly succeeded in bankrupting them but they survived.

The next owner spent a fortune on improving the house and finally went bankrupt, dying penniless in France. The next owners were partners in a brewery, which later became Truman's Brewery, so the expensive up-keep of the house did not bother them. The house took on a party atmosphere in 1907, when Sir Daniel Gooch bought the house and the estate rang out to the sounds of shooting parties and grand balls that were held at weekends, but all that ended with the outbreak of the First World War.

As war broke out the house was requisitioned as a hospital and had nearly 100 beds. Sir Daniel Gooch played his part by ensuring that the hospital had the most up-to-date equipment and his wife supervised the nurses. The grounds were used by the Army for training and parades. One of the latter was held in October 1914, when King George V reviewed 15,000 men. Later, General Kitchener did the same.

The next owner unfortunately died before he moved in, but his wife Christine Hanbury and their son took up occupation. With the outbreak of the Second World War in 1939, she allowed the Red Cross to use the house and it once again became a hospital. A prisoner-of-war camp was set up in the grounds. In 1944, the SAS moved in and made it their headquarters. There is a story that, in one drunken session, a jeep was driven up the staircase for a bet. Lady Hanbury came out of her rooms to investigate and could not believe her eyes when she saw the vehicle blocking the stairs. She is reported to have said, 'Gentlemen, I believe you have taken a wrong turning.'

They had to dismantle the jeep to get it down. When the SAS moved out it is said that they had acquired more weapons and ammunition then they had signed for and if found out they would be in trouble so they buried it in the grounds. Lady Christine Hanbury died in 1962 and the property went into decline. The council took over in 1966 and when they started gardening many of these weapons were found.

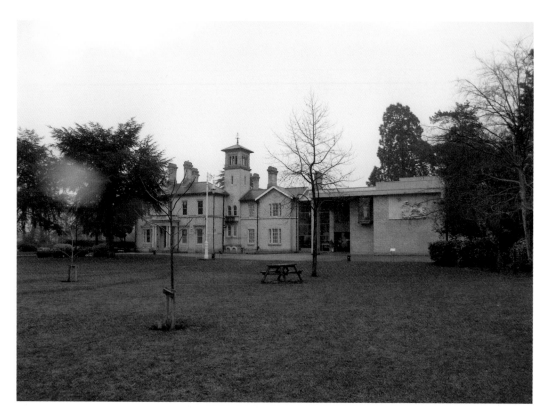

Chelmsford Museum, 2013, and an Old Photograph of Oaklands House

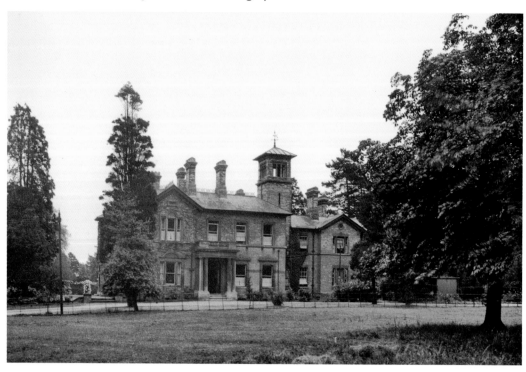

Chelmsford Museum

The museum had its roots in the Chelmsford Philosophical Society and started in the front room of the Governor of Springfield Prison, T. C. Neal. In 1843, the exhibits had outgrown the parlour and so they were moved to a building in Museum Terrace. The museum subsequently moved to Oaklands House, which was originally owned by the Abbot of Westminster, and was purchased by Alderman Frederick Wells in 1866. His house in Duke Street was too small for his growing family. He was a local brewer and coal merchant, and it is thought that the house was named after a large oak that stood in the grounds for hundreds of years until the great storm of 1987 brought it down.

In 1930, the house and grounds were acquired by the council and the Chelmsford Museum was moved there. In 1973, the Essex Regiment Museum was incorporated in the museum and was opened by the Duke of Gloucester.

This fascinating museum shows the history of Essex Regiments. One of its most prized possessions is the French Eagle, which was captured by the 44th Regiment at the Battle of Salamanca during the wars with Napoleon in 1812. Two were captured in that battle, but the second was taken off a dead French soldier and therefore did not receive the same accolade as that snatched from the hands of a French soldier who was trying to hide it.

In the grounds stands the cannon that was captured during the Battle of Sevastopol during the Crimean War (1853–1856). The gun was originally sited in front of Shire Hall but was moved to the grounds of the museum soon after some local youths thought it would be fun to fire it.

In the museum is John Slater's selection of birds and stuffed animals collected from around the world. Among the many other treasures are Stone Age axes and hammers, Romans artefacts and finds from the Middle Ages. On the ground floor, the history of such Chelmsford industries as Marconi, Crompton and Hoffmanns is set out.

The museum regularly holds exhibitions and talks, and is a must to visit.

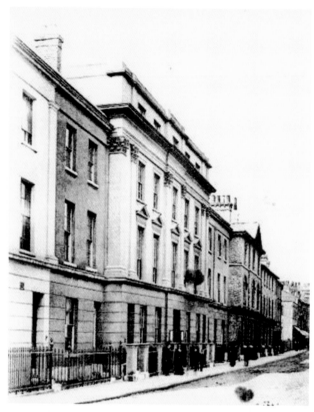

The Old Museum in Museum
Street , c. 1850, and the Cannon
Captured at the Battle of
Sevastopol in the Crimean War

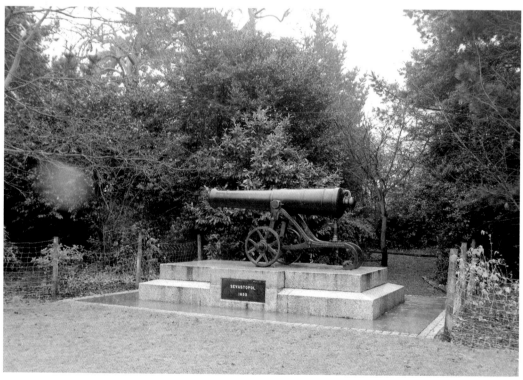

Old Moulsham Mill, Parkway

A mill has stood on the site for 1,000 years and is mentioned in the Domesday Book of 1086. The present mill was built in 1819 and has been in the ownership of the Marriage family since the seventeenth century. It was first established by twins aged seventeen.

During the eighteenth century, the price of flour rose so sharply that many families were starving. In April 1772, a riotous crowd, estimated to be in the hundreds, armed themselves and set off to the flour mills and stole a number of sacks of flour, which they loaded on to carts and sold in Chelmsford market. The authorities were in fear of their lives and sent for the troops to protect them but none answered their call.

During 1860 and 1890, extensive repairs were carried out on the mill, which ground corn that had come from Maldon by barge along the Blackwater and Chelmer Canal. During the nineteenth century the mill was converted from being water-powered, relying on the flow of water, to an engine which burnt coal and also came by barges pulled by horses.

The new roller milling method was so successful that in 1899 a new flour mill was built in New Street, next to the railway. Barges were no longer required to bring coal for the machinery and flour could be conveyed by train to markets in London. When it arrived at its destination it was taken by horse and cart to the bakers. Until 1950, the family bought their corn at the Corn Exchange in Chelmsford from local farmers.

The Old Moulsham Mill closed in 1972 but, in 1983, it had major reconstruction and was converted into a business and craft centre, with over fifty licences.

W. & H. Marriage is one of oldest milling companies in the country and has been in business since 1824. After six generations, it is still a family-run business.

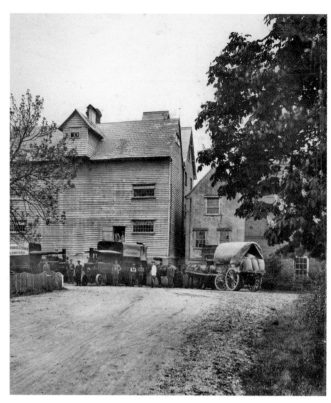

The Old Chelmer Mill,
New Street, 1900s,
and the Chelmer Mill,
New Street, 2013
(*Copyright: Marriages*)

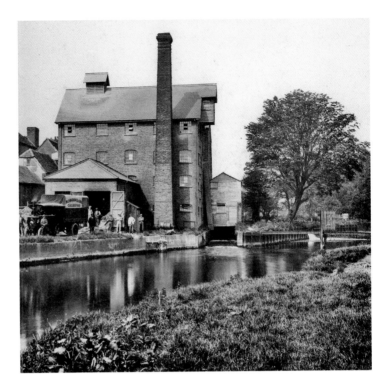

The Old Moulsham Mill, Parkway, Late 1800s, and the Old Moulsham Mill, 2013 (*Copyright: Marriages*)

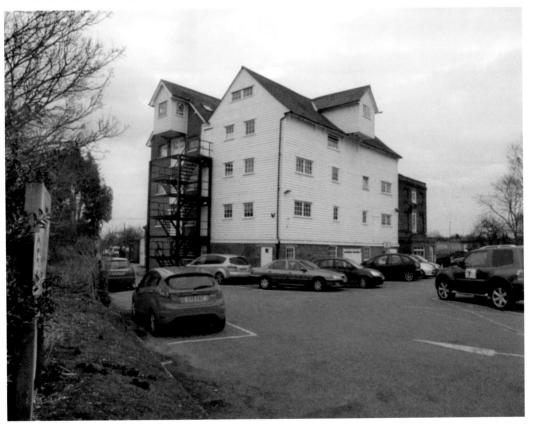

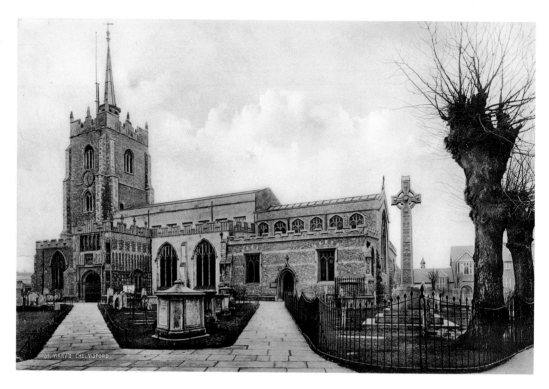

Chelmsford Cathedral, 1914 and 2013
(*Copyright: Chelmsford Cathedral*)

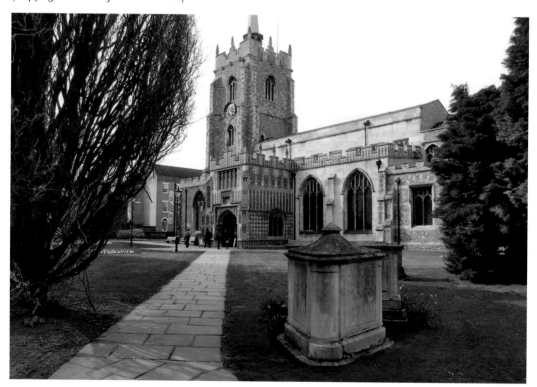

The Cathedral

The original church was built in the thirteenth century and a bell-tower was added towards the end of the fifteenth century, making it stand out at the upper end of the High Street.

As darkness fell on 17 January 1800, gravediggers had just finished digging a new grave at the side of one of the main pillars that supported the church roof, and had gone out to join the market traders and locals in one of the many inns. After a hard days work there was much drinking, laughter and singing. Suddenly, there was a tremendous crash which shook the buildings. For a moment there was silence. The music stopped and bewildered people rushed into the streets, where a thick cloud of dust hung in the air. Bemused people wondered what had happened! Was it the end of the world? Gradually, news filtered through that the church roof had collapsed. There is no record whether anyone was killed or injured. When rescuers entered the building, a great sheet of lead hung over the organ, which was not damaged but covered in a layer of dust. The church was closed until September 1803, once enough money had been raised and approval for rebuilding given. The architect was John Johnson, who also built Shire Hall.

Just over 100 years later, in 1914, the church became a cathedral when the Diocese of Chelmsford was created and the first bishop, Revd J. E. Watts-Ditchfield, held a service.

It is recorded as the smallest cathedral in England and has many interesting features, one of which is on the south-east corner, where there is a figure of St Peter, which faces towards St Peter's of Bradwell-on-Sea. It was carved by T. B. Huxley-Jones. There is also a painting of the Tree of Life, a bronze statue and a wooden altar frontal, which traces the journeys of St Cedd.

During the Second World War, many American airmen were stationed in Essex and a great number of them gave their lives. There is a memorial in the cathedral to these brave men.

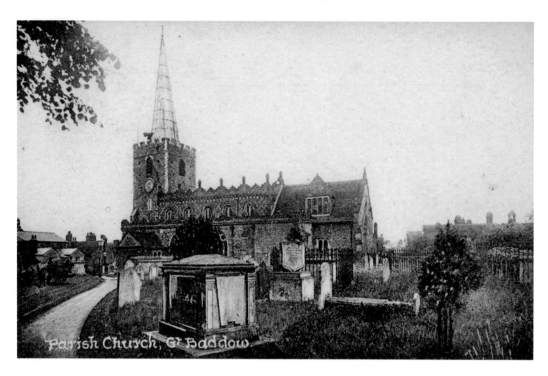

St Mary's Church, Great Baddow, 1900s, and St Mary's Church, 2013

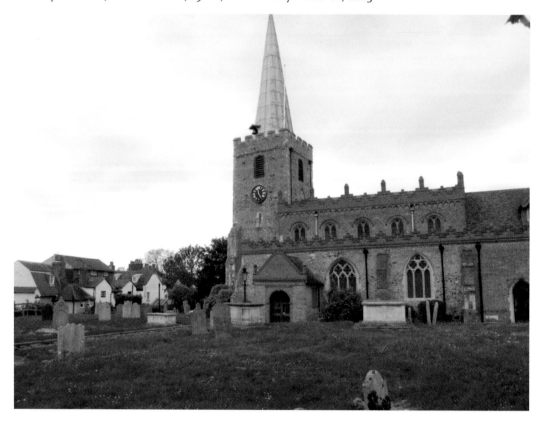

St Mary's Church, Great Baddow

This is one of the finest looking churches in the district. Although it is thought that there was a church on the site prior to 1172, this is the first recorded date that can be found to verify the fact that Maud, daughter of the Earl of Gloucester, initiated the building of the church. At first the church had a Norman nave and chancel but during the next three hundred years the church was transformed by the addition of a tower and north and south aisles to the nave. It is thought that the De Badewe family, who owned a great deal of land in the area, may have financed the alterations.

In 1381, men of Essex assembled in the churchyard under Jack Straw and then marched on London. There were a number of reasons for the uprising but the main one was that Richard II had imposed a poll tax of 5d to help pay for the war in France. It was the third tax in four years and it was the final spark that lit the flame of rebellion. When the tax collector rode into Fobbing to collect the King's dues, he was thrown out. The Authorities sent in the Army to support him and punish those who refused to pay but these trained soldiers were also forced to beat a retreat. The trained soldiers were also forced to retreat! Under Wat Tyler, a Kentish man, the rebels marched onto London to plead with the King. On the way they broke into government buildings and burnt the tax records. The fourteen-year-old King, who showed great bravery, rode out and met the peasants, first at Mile End. Then, he or those with him who wanted to get the rabble out of the city met them at Smithfield. At first the King agreed to their demands, but the second time there was some misunderstanding and the Lord Mayor slew Watt Tyler. The King then went back on his word, saying that he had agreed to their demands under duress. The rebels were hunted down and executed.

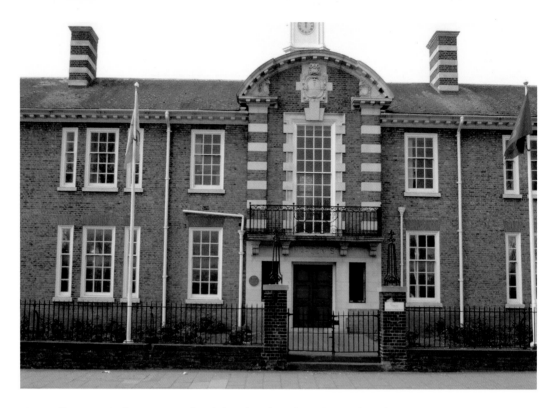

Marconi's House Before Restoration (*above*) and Undergoing Major Alterations, 2013 (*below*)

Marconi's

It is claimed that Chelmsford has the honour of being the birthplace of radio and that Marconi invented it, but there were a number of inventors experimenting with radio elsewhere in the world during the late 1800s. Two of these included Heinrich Hertz and Nikola Tesla. Marconi, who was born in 1874 in Bologna, Italy, improved the invention. He travelled to Britain in 1896 and filed a patent, and then opened the first wireless factory in Hall Street, Chelmsford, employing fifty people. Soon, he was carrying out a demonstration on Salisbury Plain for officials of the Army, Navy and the post office.

In sixteen years his business expanded and he had to look elsewhere for bigger premises. He then decided to build a new factory in New Street. The very first broadcast was carried out by Marconi but it was a one-off broadcast by Dame Nellie Melba in June 1920, using a cobbled-together microphone made from a telephone mouthpiece and a cigar-box. She did the same thing in Paris. The first regular broadcasts, and I emphasise regular, were done, not by Marconi, but by Peter Eckersley in 1922, who broadcast from the Cock and Bell public house in Writtle. He was an ex-RAF engineer and his broadcasts went out every Tuesday lunchtime.

Soon Marconi was broadcasting from a small hut, just down the road from the public house, for half an hour a week but had to listen out for military signals every seven minutes. Marconi carried out experiments at his Writtle plant and gradually improved the sound of radio. The Marconi site covered 25,000 square yards and had a 450-foot mast with warning lights on top that could be seen at night for miles around. The factory college attracted students from all over the world and carried out experiments to keep abreast of new developments in the wireless world.

The social side of the life of the company was not forgotten and playing fields, where staff could play football, cricket and tennis, were set aside. Marconi also provided a clubhouse where staff could mix and play snooker, pool and darts.

During the Second World War, the factory was an obvious target for the German bombers and in 1941, the factory was hit, killing seventeen people and injuring twenty-nine. In one of the earlier raids, the mayor and his family were killed by a bomb on their house in New London Road.

In 1999, the defence division of the factory was purchased by British Aerospace. Marconi's maintained control of the military and secure communications divisions, which were based in New Street, but the factory closed in 2008 and was relocated to Basildon. The factory in New Road is listed as a Grade II building and is being transformed today, as can be seen by the photograph.

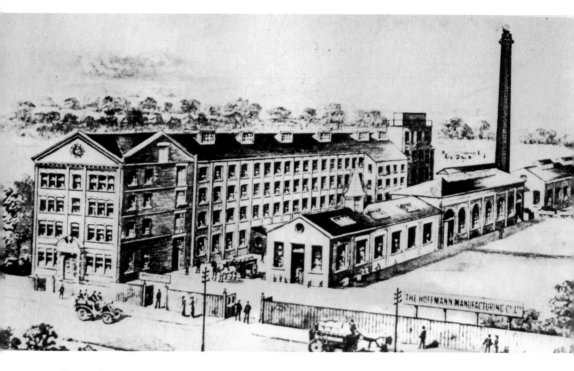

Hoffmann's Factory
The factory is shown above in 1900. Below is the approximate site of Hoffmanns today, now part of Anglia Ruskin University.

Hoffmann Manufacturing Company

This was the first company to manufacture ball-bearings in this country and the factory was housed in New Street and Rectory Road in 1898. The factory was an off-shoot of an American ball-bearing manufacturers, Hoffmann, owned by Gustav Hoffmann. He lent the money to Charles and Geoffrey Barrett, who managed the British end of the company. Its claim to fame was the accuracy of its product. During the First World War, ball-bearings were used for all types of machinery from aircraft to the machinery that manufactured them. At its height, the company had employed over 7,500 employees. It, too, was targeted during the Second World War.

In 1969, more competitors came on the scene and the firm amalgamated with Ransome and Males Bearing Company. Finally, the firm was taken over and absorbed into the Japanese NSK Company, moving to Newark-on-Trent, and the famous name disappeared. Most of the factory was demolished in 1990 and incorporated in the Rivermead Campus of the Anglia Ruskin University.

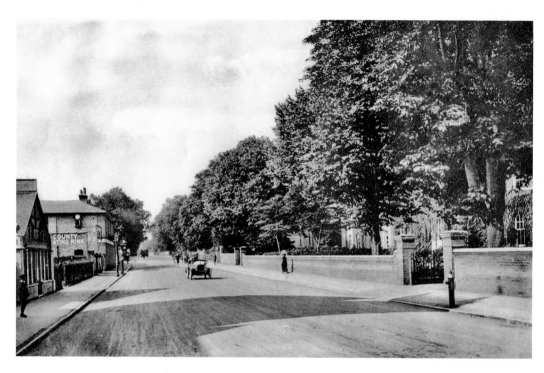

Coleman & Morton
Coleman & Morton, which was converted into a skating rink in 1919, is now a private medical centre. (*Copyright: Chelmsford Museum*)

Coleman & Moreton

This firm was established in 1843 by Frederick Greenwood and was situated on the left side of the New London Road, between Parkway and the first traffic lights at New Writtle Street, opposite the Chelmsford and Essex Hospital. For the first five years Richard Coleman managed the company, then leased it from the owners and finally bought it in 1865. Unfortunately he died a year after taking ownership. The business was inherited by his son, and he and A. G. E. formed a partnership.

The firm manufactured agricultural equipment, steam engines, man-hole covers and castings for iron bridges. In those days, they were a very progressive firm and there is evidence that they allowed their employees to hold meetings on the premises. It is recorded in the *Essex Weekly News* of 6 November 1874 that a party was held by the partners, their wives and staff, to celebrate the introduction of a nine hour day. In 1867, the iron workers at the factory set up the Chelmsford Star Co-operative Society and were joined by the silk workers of Braintree, who had formed a society in 1864. By 1868, the Chelmsford Star had 275 members.

Unfortunately, the depression in the farming industry during the latter half of the nineteenth century, caused by cheap corn being imported from America and Canada, had a knock-on effect on the firm, which was sold in 1907. A skating rink was built on the site around 1919 and a private medical centre is on it today.

Crompton's

The exterior of Crompton's has not changed over the years and today it is a chemist and doctors' surgery.

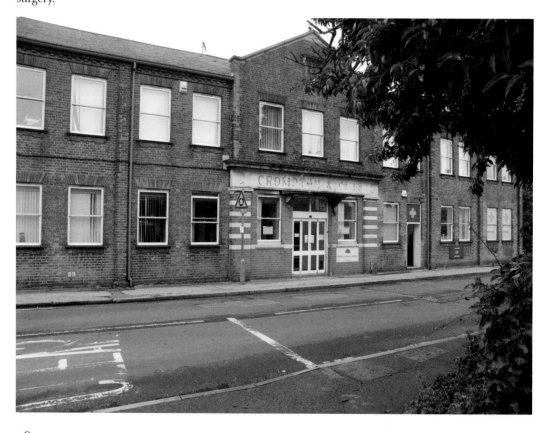

Crompton's

Crompton's premises have not changed over the years and today, they are occupied by a chemist and doctors' surgery as the pictures show.

Chelmsford is not only famous for being the birthplace of radio but Crompton, it is claimed, was the first electrical engineering works in England. It was set up by Col Crompton in Queen Street in 1878. The firm made the first arc lamps and were pioneers in manufacturing electric light generators, which were installed in Buckingham Palace, Kings Cross station and the Law Courts. Unfortunately, in 1895, the factory was badly damaged by fire and Crompton's took the opportunity to build a new factory in Writtle, named Crompton & Co. but nicknamed the 'Arc Works'.

In 1927, Col Crompton went into partnership with an electrical engineer called Frank Parkinson. During the Second World War, German bombers frequently sought out the factory because of its valuable contribution to the war effort, despite the town being covered by thirty barrage balloons. In July 1942, during a particularly bad raid, the factory was hit and seven workers were killed. Later that year, 4 more were killed and, in the same raid, 500 properties were damaged. Towards the end of the war, on 19 December 1944, a V2 rocket hit the factory killing twenty-nine.

In 1969, the firm was taken over by Hawker Siddeley and moved elsewhere but the site was taken over by Marconi for their radar system. In 1992, the factory was closed and later demolished, just leaving the frontage. The founders of Crompton and Parkinson have not been forgotten as 'The Village' was built on the site and streets named after these two entrepreneurs.

Britvic

It is difficult to believe that the giant Britvic Company started from a small chemist shop in Tindal Street during the nineteenth century. At first, it was called the British Vitamin Products Company. The drinks were water-based, home-made soft drinks. In 1938, the business was taken over by James MacPherson & Co., and under their direction the firm expanded and set up a headquarters in Broomfield Road. They began to sell fruit drinks and exported them to more than fifty countries. In 1971, the company took on the name of Britvic and in May 2005, they bought the soft drinks and distribution business of Cantrell & Cochrane. In 2012, the firm moved its headquarters to Hemel Hempstead but retained its factory on the Widford Industrial Estate. On 14 November 2012, the company merged with Scotlands. It also has regional offices in Dublin and France. It was acquired by Showerings of Shepton Mallet and subsequently became a division of Allied Breweries. The company owns a number of brands in the UK: Britvic, R. Whites Lemonade, Tango and – the favourite of tennis players – Robinsons. Apart from this business, it has a licence to bottle Pepsi Cola products. This is a success story and the business seems to have expanded every few years and continues to go from strength to strength. Unfortunately, in May 2013, the firm announced that it is moving out of Chelmsford.

This and opposite page: **Britvic Offices and Factory** The Britvic offices on Broomfield Road are now sadly empty. The Britvic factory is shown in 2013, soon to be closing down.

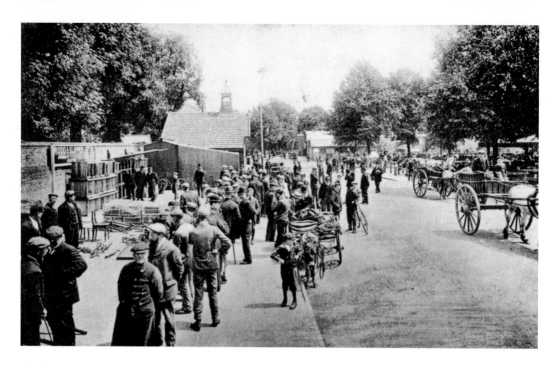

Chelmsford Market, 1890, and Market Site, 2013
(*Copyright: Chelmsford Museum*)

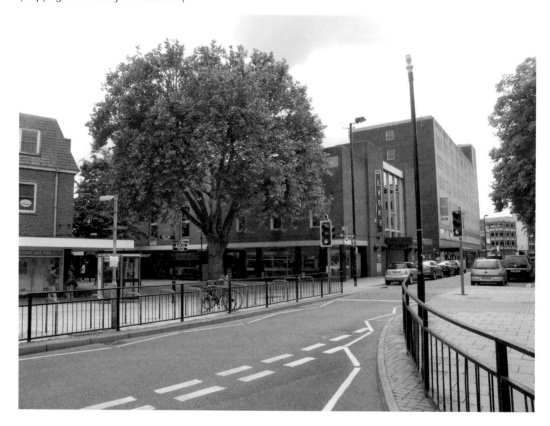

The Market

In 1199, King John granted the Bishop of London, William of Sainte-Mère-Église, a charter to hold a market in Chelmsford. The following year he reinforced this charter and gave Bishop William the right to allocate plots in the market area. Ironically, King John visited Chelmsford on 21 March 1201 on his journey from London to York and granted a right to hold a three day annual fair, commencing on 1 May. The charter allowed the Bishop to establish the town and to make money for the church by selling freeholds in the market place. Entrepreneurs of the day, who included some from France, took the opportunity of this investment. The Bishop charged an annual fee, like a leasehold, for the plots, but they could sell them on if they wanted to with the Bishop's permission. At first, the market place was a triangular shape, with the church at the top and stalls on each side of the road leading down to the river. The more expensive plots were as long as 600 feet. As time went on, more permanent buildings were erected. From the fourteenth century onwards, a channel ran down the centre of the High Road, eventually discharging into the river, which became contaminated with animal and vegetable waste.

At that time the town's main public water supply was a spring-fed conduit, which came from Burgeyswell to the town centre through underground elm pipes. There were a few other public wells. Around 1850, there was an outbreak of cholera and the local Board of Health appointed Edward Cresy to report on Chelmsford's sanitation problems. Following his report, James Fenton, a surveyor, was asked to produce plans for the water supply and a waste water plant at King's Head Meadow. Householders could connect to the cast-iron sewer system if they were prepared to pay for the connection. Reservoirs were built at Burgess Well and Wood Street.

One of the most successful merchants of Chelmsford was Thomas Mildmay, whose wealth originated through the Dissolution of the Monasteries. One of his sons became auditor to Henry VIII and was a member of the Court of Augmentations. For 300 years, the family was prominent in Chelmsford. Thomas Junior acquired the former Dominican Friary and later obtained the Manor of Moulsham with its 1,300 acres.

In 1880, the market was moved to an area behind the Corn Exchange. Cattle and sheep were driven up the High Street after the Second World War. The local Board of Health bought the market for £2,000. The modern site of High Chelmer is under the multistorey car park.

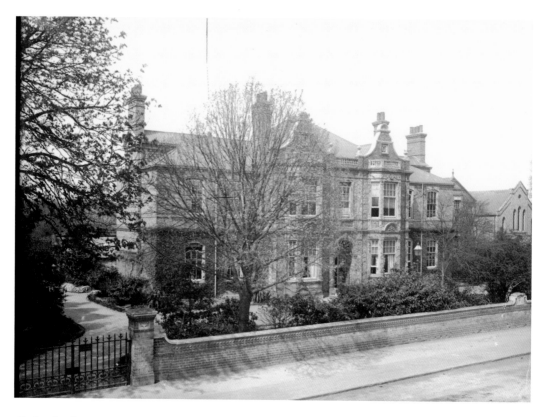

Chelmsford & Essex Hospital, London Road, 1900 and 2013

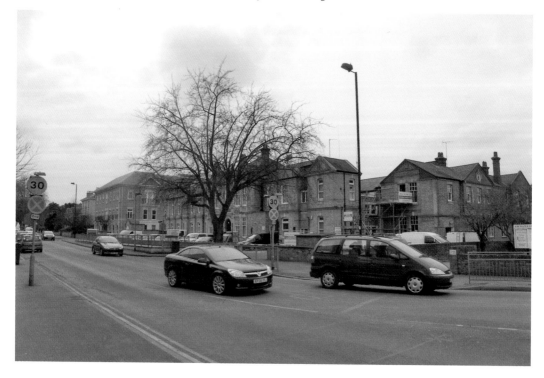

Chelmsford & Essex Hospital

Chelmsford has had a dispensary for the poor since 1818, which was run on a voluntary basis by the town's physicians and surgeons who gave their time for free. An infirmary was set up in Moulsham Street in 1870, but it proved unsatisfactory as it was situated next to a public house and was very cramped. During one cholera outbreak, the authorities were forced to erect a tent to treat the sick because of insufficient room.

On 27 July 1880, the Infirmary Committee met and decided that because of such a high demand in the area, a purpose-built infirmary was needed. The committee, under the Presidency of Thomas C. W. Trevor, who was the Lord Lieutenant of Essex, appealed for funds, and the money came pouring in from all classes of citizen, high and low, and by 1882, £4,680 had been raised. A site for the hospital became available in London Road between Chestnut Villas and the Baptist chapel. Plans were prepared by Frederic Chancellor and Charles Pertwee, and advice from Edward Hunt and Dr James Nicholls, who were highly-qualified doctors, was sought.

The infirmary was opened by the Countess of Warwick in 1883. As often happens with large projects, it overran its budget by nearly £1,000 and needed a further £10,000 to keep the hospital running. The committee resolved to raise the necessary funds and set about with sales of work. They sold light refreshments in the waiting rooms, and held fetes, carnivals and concerts. They placed collecting boxes in all the local churches and built a collection box into the outside wall so that the passers-by could contribute.

The original hospital comprised of a two-storey building, which had an accident ward on the ground floor with four beds for men on one side and two for women on the other. On the upper floor there were two six-bed wards. Private patients had two single-bed wards with bay windows. The hospital also had a dispensary, doctor's rooms and a mortuary. The rooms were distempered green and were well-lit with gas lighting. Wards were named after the large donors.

In 1946, the hospital was taken over by the National Health Service and it continued as an infirmary. Once Streptomycin had been discovered as a cure for Tuberculosis, there was no longer the necessity for Broomfield to continue as a specialist Tuberculosis hospital and it started working with Chelmsford and Essex as general hospitals. Gradually, Broomfield expanded and slowly Chelmsford and Essex went over to a day clinic and provided women with an excellent breast screening service. After 130 years of service to the public, I understand that there are plans to close the hospital and give it over to development. It will be sad to see, after all this time, another of Chelmsford's old buildings reduced to rubble.

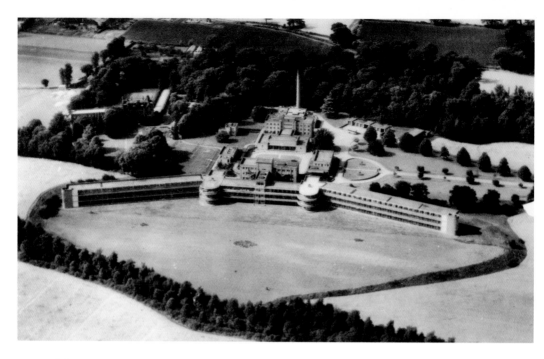

Broomfield Hospital, 1940 and 2013
(*Copyright: Broomfield Hospital*)

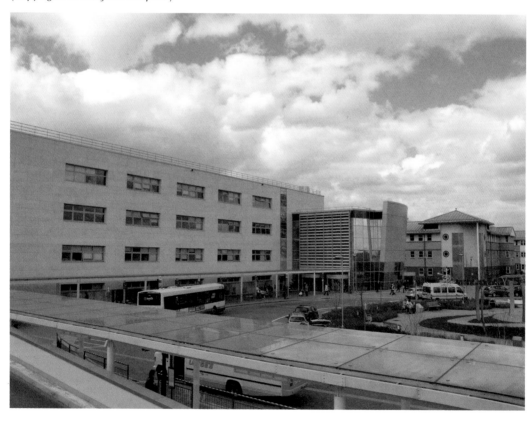

Broomfield Hospital

The Edwardian family of Radcliffe owned the estate called Little Dumplings and built a mansion house on it in 1904. Thirty-one years later, in 1935, the daughter, Constance, sold it to the Essex County Council for them to build a hospital. Tenders were asked for and Staverton won the contract to build Broomfield Court Sanatorium for £22,993. Building started two years before the Second World War, in June 1937, and the hospital was opened in May 1940. In this day and age it would not be tolerated but at first the hospital would only admit men.

It is claimed it was the first hospital in Essex to treat tuberculosis, which was rife during the 1930s and 1940s until the drug streptomycin was brought in. The hospital was built facing south, with wings that caught the sun for the tuberculosis patients, who were wheeled out on to the balconies, even in winter. The cure for tuberculosis in those days was sunshine, fresh air, rest and good food. A lot of the food was grown in the grounds. The average patient stayed for between six months and four years. Boredom was a huge factor and the highlight of the week was a film show on Friday night, when the porters, with four patients to a bed, raced down the corridors in an attempt to secure the best places in the hall.

The Essex County Hospital, as it was then called, played its part in the war, and 50 per cent of the 312 beds were allocated to servicemen. In those days, it had under a hundred staff who, it was said, were 'one big, happy family'. The first physician, superintendent and administrator was Dr William Yell.

As tuberculosis began to decline, Broomfield gradually changed to acute general care. It was run by the North East Metropolitan Regional Hospital Board when the National Health Service was founded in 1948. It was not until 1959 that it started admitting women, when the first six babies were born there. Around this time, the hospital started branching out into other areas of medicine, such as general surgery, general medicine, geriatrics, and a large outpatients department. By the 1960s, Broomfield had become a general hospital, but still retained one ward for chest infections.

In 1984 the hospital again expanded to include an Accident & Emergency department, pharmacy, rehabilitation department, more operating theatres, and an intensive care unit. In 1953, the first student nurse arrived from the Commonwealth. The hospital has been visited by a number of dignitaries over the years. In 1981, Enoch Powell opened a crèche to help the recruitment of student nurses. In 1981, Dame Elizabeth Coker cut the first turf for the new development. In 1983, Princess Anne opened the CAT scanner unit. Frank Bruno opened a new screening unit and John Major undertook the topping ceremony. As hospitals have closed throughout the county, Broomfield hospital has taken on more and more patients.

St John's Hospital
St John's Hospital in
1960 (*above*) and being
redeveloped in 2013
(*left*). The old gate of the
Workhouse has hardly
changed over the years.
(*Top image copyright:
Chelmsford Museum*)

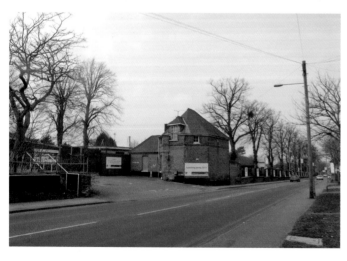

St John's Hospital/ Workhouse

It is believed that the site of St John's Hospital was originally one of the Army barracks erected around 1794 to accommodate the 8,400 troops billeted in the Chelmsford area during the Napoleonic Wars. In 1837, a workhouse was erected on the site and the bottom picture shows the main gate where an applicant would have to knock to gain access. On entering the workhouse, a family would have been split up and the sexes separated. The workhouse catered for the desolate, homeless, disabled, orphans or the old, provided they had lived in the parish for two years. Those that could were put to work and paid, according to their abilities from 5d to 1d for children. They were given three meals a day and a quantity of ale. Not everybody who fell destitute was put in the workhouse. If a man was working and fell ill, he and his family were not immediately put in the workhouse but were given a shilling to tide them over.

The workhouse was converted into a hospital, which had a maternity ward and carried out nose and throat operations. It also had a thriving blood testing unit.

There was a leper house in Chelmsford before 1293, but in 1776, a parish workhouse was built in New Street, along with four others throughout the district. The one in New Street had fourteen rooms and was built on the old almshouse site, which had been very expensive to maintain. The authorities set up trustees to manage the workhouse, who borrowed money and received some out of the rates. Within eighteen months of the building opening the loan was repaid. One can imagine desperate people calling at the gates of the workhouse during the Victorian period, begging for help.

Inmates were given breakfast, but if they had not worked hard enough, they were not given another meal until they had finished. Their meals consisted of beef and pudding three times a week, plus cheese and butter, and they grew their own vegetables. They had nine gallons of beer a week; this was because water was polluted. They were given a clean shirt once a week and their heads were combed for lice. Fifty people lived in the workhouse including the master, his wife and children.

A school was set up which educated fifty boys and thirty girls. The school was supported by the local people and the magistrates gave £30 a year. Children were taught the 'three Rs' and the girls were taught knitting and needlework.

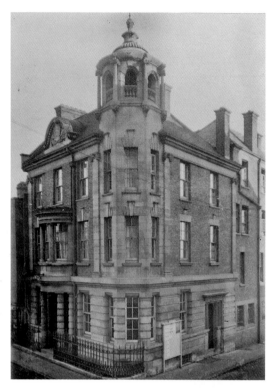

Chelmsford Police
Chelmsford's first police station in Waterloo Lane, which was conveniently opposite Shire Hall. Below is the site of the old police station in 2013.

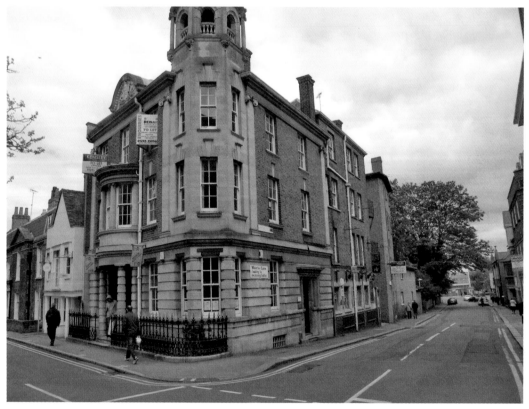

The Police

At first, the authorities set up a nightwatchman, who patrolled the streets, but when the County Police Act came in 1839, Essex was one of the first counties to take advantage of it, and formed the Essex Force in 1840. After some deliberation, they appointed Captain Hardy, a man who had a great deal of experience commanding men in the Navy. Throughout the county, they appointed 1,000 constables and 15 superintendents.

The first police station in Chelmsford was in Waterloo Lane. In those days a new constable did four weeks training before being released onto the streets. They worked seven days a week and it was not until 1910 that they were given a rest day. They had no breaks during the long day, and were expected to eat on the beat and walk 20 miles a day. They were paid £1.10s a week, which was the same as a farm labourer, and was just enough to feed a family. A breach of discipline was severely dealt with and constables were fined for such things as being caught asleep on duty, being drunk or wandering off their beat without good cause. They could be reduced in rank or – in extreme cases – sacked. The punishment for criminals was the stocks, whipping by birch or cat-o'-nine-tails, or hanging, which took place at Gallows End, now Primrose Avenue.

Out in the countryside, alone, with no means of communication other than a whistle, constables were frequently assaulted and occasionally murdered. Sergeant Eves came across a gang stealing wheat from a farm. With no means of summoning support, and with great courage, he remonstrated with them. They attacked him and cut his throat. The gang were caught and John Davis, who actually committed the murder, was finally hanged from the gate of Chelmsford Prison. Thousands gathered from miles around and stood and watched as Davis swung. Sergeant Eves' widow received a pension of £15 per year and the public raised £400 for her.

During the nineteenth century, Chief Constable McHardy introduced a merit medal for distinguished conduct. Twenty constables and ten sergeants received the award. The constables received an extra shilling a week while the sergeants received two.

In 1910, the Chief Constable of Essex acquired the first police car, which was hired for £50 a year.

Essex Police Training School, Arbour Road, 1930 and 2013
(*Copyright: Essex Police Museum*)

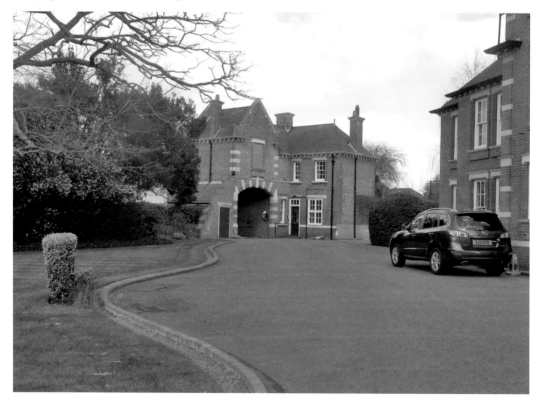

Prisons

The first known prison was built in 1600 at the side of the Stone Bridge. It was named a house of correction and was meant to give a short, sharp shock to prisoners who were sentenced to one to two weeks for petty crimes, such as prostitution and fraud. There was another jail behind that one, for criminals who had committed more serious crimes like highway robbery, horse stealing, and the stealing of handkerchiefs or a man's tools of his trade.

King George IV wanted to see all prisons used for felons, vagrants and debtors. People who were awaiting trial were supposed to be kept separate, but this was not possible because the prison was too small. The Stone Bridge Prison was near to the river and was subject to dampness and subsidence, and therefore not very secure. One prisoner, using a stick, dug himself out of his cell; another, who had one hand, just walked out.

The first brick of Springfield Prison was laid in 1822. The first governor was Thomas Neal, who also founded the local philosophical society as well as the museum. As the wings were completed, they were occupied. The prison had 214 cells and was supposed to house only 272 prisoners, but it had to take prisoners from the other two jails as they were closed down. As a result of the overcrowding, prisoners had to sleep wherever there was space, often in cupboards and corridors.

When they were allocated a cell, the beds were of stone. They were given only two blankets and there was no heating, even in the depths of winter. Part of the prison was set aside for boys as young as eight years old. They were subjected to between twelve and fifty strokes of the birch. Men were given the cat-o'-nine-tails, which was a whip with lead on the end of its nine leather thongs. It could strip a man's flesh down to the bone. Life was hard and became even harder when two treadmills were introduced. Men and women were subjected to ten hours a day pounding on the wheel. Later, this punishment was stopped for females. Prisoners were allowed a bath once a month in the open prison yard. Their diet consisted of 1½ lbs of bread and 2 pints of beer (this was stopped in 1834). After three months they were allowed food brought in by their relations. At that time, rations were also increased to include onions and 1 pint of soup three times a week.

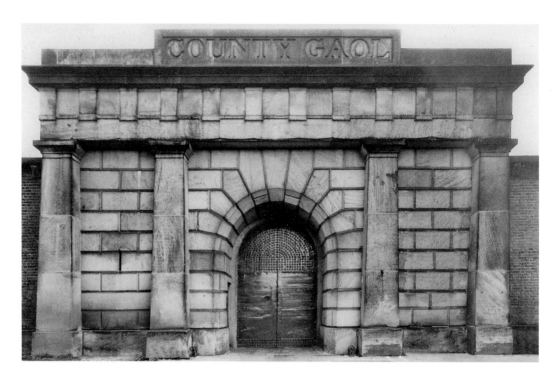

Springfield Prison Gate, Late Eighteenth Century and 2013

The external walls of the prison were impossible to climb as they were 20 feet high. They did have a chapel and an infirmary. Sentences were either short, normally from one month to three, or they were hanged. If they were lucky they were transported. From 1822 until 1868, prisoners condemned to die were hanged over the entrance in full view of the public. It was considered a day out by the population of Chelmsford and the surrounding districts. Stalls were set up to sell food and liquid refreshment. After 1868, the condemned prisoner was hanged in the prison itself, a bell was rung and a black flag was flown to indicate that the sentence had been carried out.

Different hangmen used different lengths of rope. A short rope strangled the condemned man and he took longer to die, whereas the longer rope broke his neck and death was almost instant. Forty-four prisoners were hung in the jail and only one man survived; they tried to hang him seven times and, finally, after the last failure, committed him to life imprisonment. James Cook was the youngest prisoner to be hung at Springfield. He was only sixteen, and was condemned to death for setting fire to his employer's barn.

In 1978, the prison caught fire and it was necessary to completely refurbish it. Today, the prison is a young persons' institution.

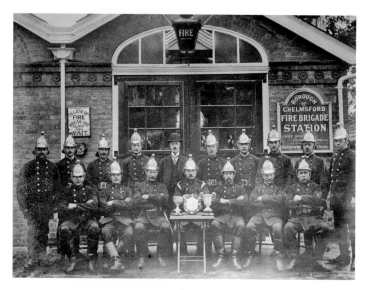

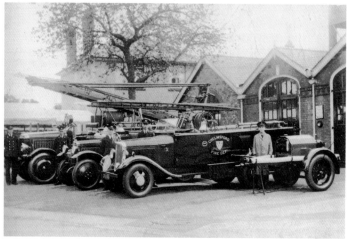

Fire Station
The fire station
in Market Street/
Threadneedle Street, 1914
(*above*), 1930 (*left*) and
2013 (*below*). (*Copyright:
Essex Fire Brigade*)

Fire Brigade

The Romans fought fires with a simple handpump and buckets of water. When they left, Britain went into the dark ages and firefighting was left to the individual. It took the Great Fire of London in 1666 to change the attitude of people, and a property developer, Nicholas Barton, started up an insurance company which had a fire service that only attended fires of those that were insured with it. To enable the fire brigade to tell which premises to attend in the event of fire, the building had a badge on the front. If you were not insured, you were left to your own devices. Soon, other companies were set up to take advantage of this lucrative business.

In 1823, Edinburgh set up its own fire brigade and this was followed by a number of companies in London merging and becoming the London Fire Engine Establishment. The handpumps of earlier years were replaced by steam during the mid-eighteenth century. At this time, other areas of Britain had volunteer or town fire brigades, and it is estimated that there were well over 1,000 fire services in the country mainly run by local authorities. It was obvious that something had to be done to ensure that there was a uniform service throughout the country and, with the Second World War inevitable, the National Fire Service was established in 1938. This ensured that most equipment became standardised and brigades shared methods of firefighting. Two years after the war ended, the fire services were handed over to the county councils and boroughs.

The Chelmsford Fire Brigade had a station in Market Road, opposite Threadneedle Street, near the old cattle market. It was vacated in the 1950s and was demolished in the 1960s to eventually make way for the shopping centre. The brigade was stationed in the Oasis fire station at the top of Springfield Road and moved to the new station in Rainsford Lane in around 1959.

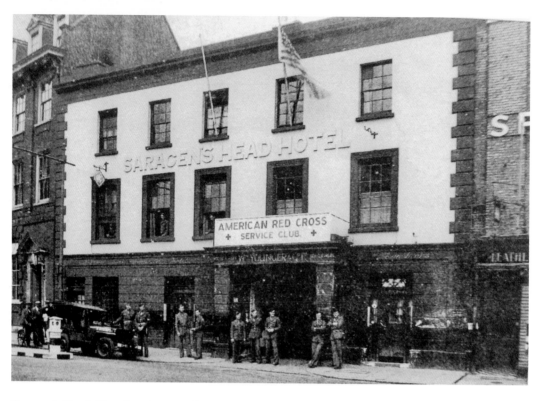

Saracen's Head, Showing the American Red Cross Club in 1942, and 2013

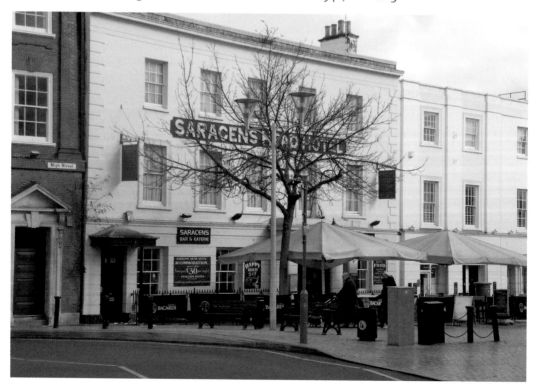

Saracen's Head Inn

One of the leading coach houses in Chelmsford is the Saracen's Head, which dates back before 1539. In his *Tour Thro' the Whole Island of Great Britain* in 1724, Daniel Defoe mentions it and other inns in Chelmsford, and stated that Chelmsford was 'full of good inns'. In 1718, Thomas Nicholls bought the inn for the enormous price, in those days, of £650, and set about modernising it. Unfortunately, he ran out of money and failed to pay the mortgage, and the inn was repossessed and taken over by William Taylor.

The inn held grand balls, meetings and the annual Floweriest Banquet. The Beefsteak Club was set up in 1768, which met in the cellar of the inn. The club had forty members who met once a month nearest to the date of the full moon, so that they would have light to see themselves home. When Shire Hall was built in 1791, it took business away from the inn.

The Inspector General of the post office, Anthony Trollope (1815–82), wrote parts of his novel *Barchester Towers* while residing in the inn. He produced the novel in weekly parts. Two clergymen were talking in the pub about the book and one of them said 'Confound that Mrs Proudie, I wish she was dead'.

Trollope, who was sitting in the inn writing, overheard him and shouted over his shoulder 'Gentlemen, she dies in the next week's!'

During the Second World War, the inn was taken over by the American Red Cross Service Club, the equivalent to our NAFFI. American servicemen came from stations such as Great Easton, Willingale, Boreham, Rivenhall and camps from all over Essex to meet up, drink their cool beer and read the American papers. Many Americans who served in the forces during the war come back to the pub to reminisce. The inn is still going strong, as can be seen by the recent photograph.

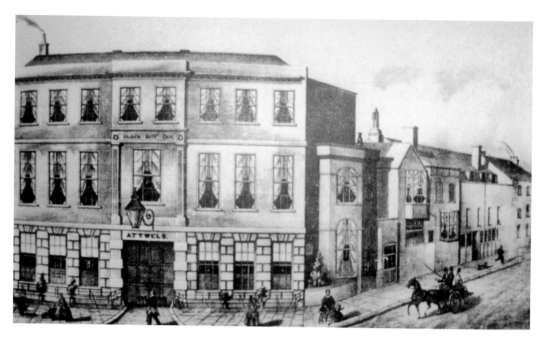

Black Boy Inn

Above, drawing of the Black Boy Inn, from the 1800s. Below, the site of the Black Boy Inn in 2013, which is now the clothes shop Next on the corner of Springfield Road.

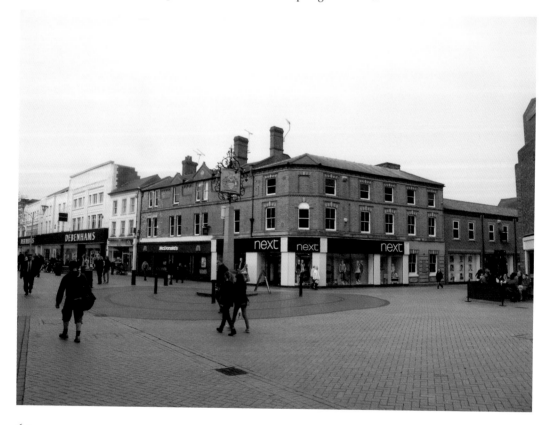

Black Boy Inn

The Black Boy Inn once stood at the junction of the High Road and Springfield Road, where a plaque was erected in 1988. The original inn went back to the sixteenth century when it was called The Crown Inn and was a staging post on the Harwich–Colchester road. It was renamed The Black Boy later in the sixteenth century. It went through many changes during the intervening century but a hundred years later, it was completely rebuilt. It must have been a very salubrious establishment as George IV stayed there as did the Duke of Wellington, who won the Battle of Waterloo. It had a very large ballroom and could stable nearly fifty horses. With the advent of the railway during the nineteenth century, it was no longer necessary for passengers to break their journeys as they could reach most destinations in one day.

Charles Dickens stayed in the inn when he covered an election in Chelmsford for the *Morning Chronicle.* He was not impressed with the town and said, looking out at the pouring rain, 'It is the dullest and most stupid place on earth.' He continued, 'the only things to look at are the two immense prisons, which are large enough to hold all the inhabitants of Chelmsford.' It is said that he depicted The Black Boy in his *Pickwick Papers*. Perhaps he was having a bad day when he visited.

The new inn had stables that could house fifty horses, which gives an indication of the size of the building. In 1835, the first meeting of the Board of Guardians of the Poor Law was held there, where it was agreed that five more parishes would be added to the list. The inn was demolished in 1857 and now the large fashion shop Next occupies the site.

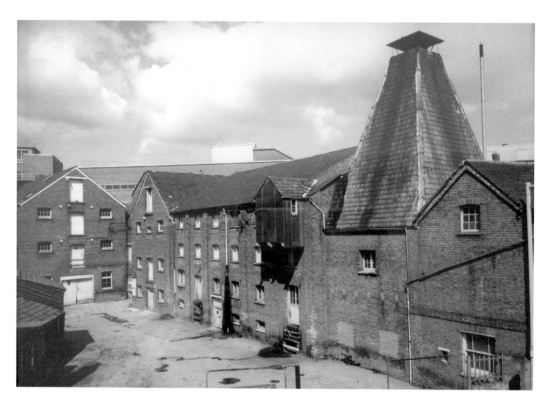

Gray & Sons, 1828 and 2013
(*Copyright: Gray's Brewery*)

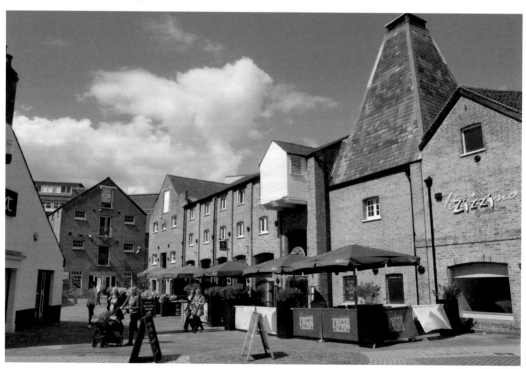

Gray & Sons (Chelmsford) Brewers Ltd

There is evidence to suggest that the Black Boy Inn brewed their own beer at the rear of the inn, at the junction of Springfield Road and the High Street. In 1828, Gray's Brewery, at the back of the inn, may have incorporated part of it. It was twenty-nine years later that the Black Boy was demolished. Gray's expanded so much that they had to find additional premises and in 1870, they moved part of the business to Gate Street, Maldon, and from there were supplying most of Essex. The brewery was very successful and it continued trading until 1954, when the Maldon Establishment closed and all the business was conducted from the Springfield plant. They continued to brew their 'Mild' and 'Bitter' range until 1974, when Greene King became the main brewers. Greene King had been brewing in Bury St Edmonds since 1799. Each month it has guest beers from small local brewers such as Farmers Ales, Mighty Oak and Adnams. In 1974, Gray's Brewers moved to Rignals Lane, Galleywood, and still continues its family business and delivers ales and lagers to public houses in the area.

Outside the depot in Rignals Lane stands a Phoenix, which was inherited from the Phoenix Fire Insurance Company, who rented part of the brewery in Springfield Road.

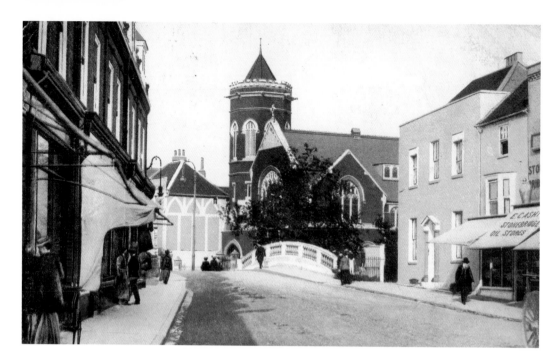

Stone Bridge, *c.* 1900, and 2013
(*Copyright: Essex Record Office*)

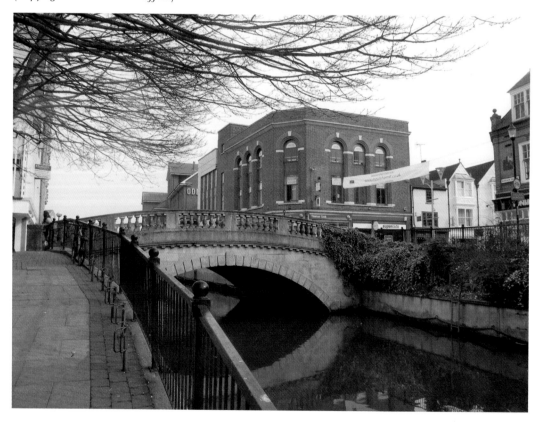

Stone Bridge

It is hard to believe that construction of the Stone Bridge, which spans the River Can, was started in 1785. It was opened to traffic in 1788 although the keystone is dated 1787. The original bridge was built in 1372 and had two piers. It joined Moulsham and Chelmsford throughout the centuries until 1761 when it became dangerous. To help matters, a wooden footbridge was built but twenty-three years later this had deteriorated and the magistrates decided that, in view of the increase in traffic and that there had been a number of floods that had further damaged both bridges, the old bridge had to be replaced. The old bridge had witnessed the grisly execution of George Eagles, whose nickname was Trudeover, because he tramped the country preaching the Protestant faith, which was against Bloody Mary's Roman Catholic religion. She reigned from 1553 to 1558. A reward was offered for his capture and eventually he was caught in Colchester, taken to London and sentenced to be hung, drawn and quartered. He was dragged back to Chelmsford where a gibbet was built on the bridge and the grizzly sentence was carried out.

It was proposed that the new bridge, which was designed by Mr James Johnson, should have one 34-feet span, instead of the two the old bridge had. In order to achieve this the river, which was 54 feet wide, had to be narrowed and this alteration later caused flooding. There was a suggestion by Thomas Telford that the new bridge should be built of iron. Luckily, the idea was turned down as I doubt it would have lasted as long as the present structure. During its long life one of the balusters fell into the river but was not recovered until some flood relief work was carried out in the 1960s. With Chelmsford centre now being a pedestrian walkway, this ancient monument should last for many more centuries to come.

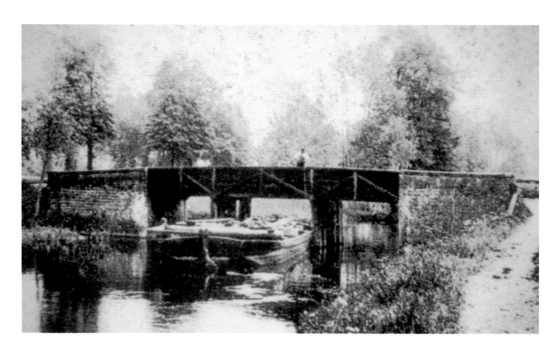

Paper Mill Lock During the Late 1800s and 2013

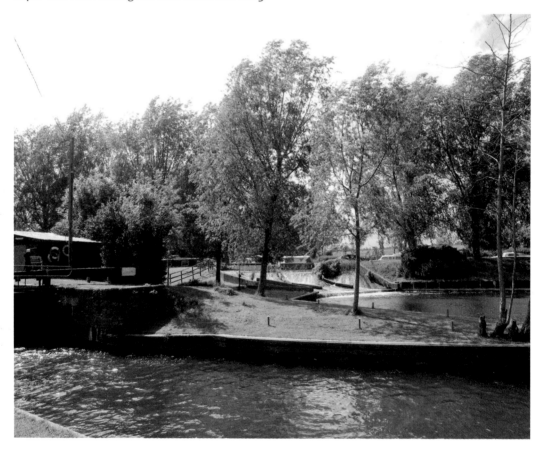

The Chelmer &
Blackwater Navigation

The Chelmer & Blackwater canal system was completed in 1797, although for nearly 100 years before that the proposal was discussed and ideas put forward but there were always objections from organisations that thought it would affect their businesses. Maldon Council objected to the plans because the canal did not pass through their town. Before the canal was built everything had to be taken by packhorse or horse and cart. Although John Rennie was appointed as the chief engineer to build the canal, he rarely visited the site and the construction is attributed to Richard Coates, who was the residential engineer. He set up home on the canal and amazingly, completed the work in four years. Having built the canal he decided to operate some barges on it. Coates' Quay is named after him and he is buried in All Saints church, Springfield.

The canal runs for 13 miles from the Springfield Basin, Chelmsford, to the sea lock at Heybridge Basin. Until 2003 it was run by the original company but is now run by the Essex Waterways Association. It has thirteen locks, starting on the A138 road through to the Heybridge Lock. The Beeleigh Lock was built and a new cut dug to prevent flooding. The navigational part of the canal is the shallowest in England and is only 2 feet deep. The 16-foot-long barges could carry 25 tons and were pulled by horses until the1960s when engines were fitted to the barges. The first gasworks in Britain was built in 1819 and was powered by coal brought up by these barges. They carried practically everything from bricks, stone, timber and general cargo, which was carried from Heybridge to Chelmsford, and on the return journeys they carried flour and grain. At one time, barges were transporting 60,000 tons a year.

With the advent of the railway at Chelmsford in 1842, the canal started to decline, although it did not impact on the canal at first as much as other means of transport.

After the Second World War the sea lock at Heybridge was improved, to enable coasters from Europe to enter and unload wood on to barges. Finally, in 1972, the last load of timber was delivered to Brown's Yard.

All along the banks of the canal beautiful willow trees are visible, which when fully grown are cut down, sent aboard to the Far East and made into cricket bats, which are exported back to England. The canal is still used for pleasure pursuits, such as canoeing and cruising along the canal in pleasure boats. Narrowboats can be hired from Paper Mill Lock and a pleasant afternoon can be spent cruising on the water and observing the wildlife, finishing up with a nice cream tea in the riverside café.

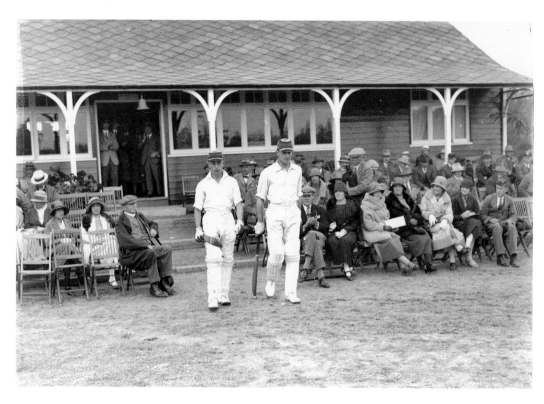

Chelmsford Cricket Club, 1970s, and the Club's Pavilion, Beehive Lane, 2013

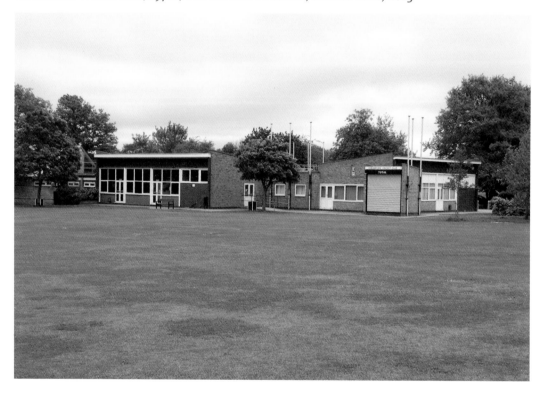

Chelmsford Cricket Club

The sport of cricket was in its infancy when Chelmsford Cricket Club was formed in around 1810. Subsequently, it is recorded that two matches were played the following year. It must have been very difficult to organise because there were no trains in Chelmsford until 1842 when the station opened. There were no buses and there was no way for the ordinary man to communicate. It was not until around 1840 that the post became available. Cricket teams or football teams tended to be arranged between estates, factories, nearby villages or army units. Chelmsford was a military town.

The first games were played at King's Head Meadow, but soon after games were played at Fairfield, which surprisingly enough is where the current bus station is.

Around 1879, the club moved to a ground near New Street, which was its home for the next thirty-two years. Unfortunately for the club, Marconi's bought the land and erected its factory on it and for a while the club was in limbo. The First World War took its toll on many young players so that it was not until 1921 that the club found a new home in Writtle Street, until the Essex County Cricket Club bought the land and, again, the club was in the wilderness. Finally, Chelmsford Council came up with a solution and in 1972, the club moved into Chelmer Park, where it has gone from strength to strength and has held fifteen league titles in the last seven seasons.

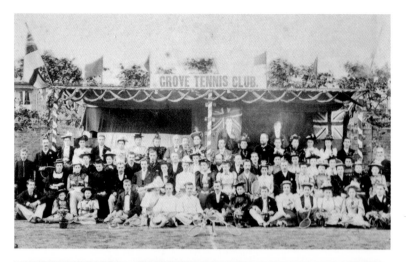

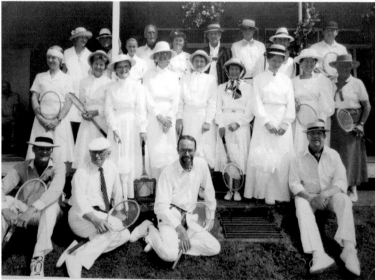

Grove (Chelmsford) Lawn Tennis Club
The Grove (Chelmsford) Lawn Tennis Club in 1893 (*above*) and celebrating the club's 100th (*left*) and 120th (*below*) anniversaries.

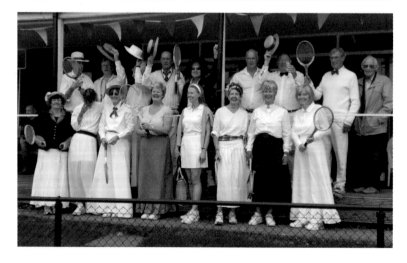

Grove (Chelmsford) Lawn Tennis Club

The final changes to the Lawn Tennis rules were made in 1882, when it was decided on the dimensions of the court, the height of the net and ball sizes. The first entry in the minute book of Grove (Chelmsford) Lawn Tennis Club was made in 1896, but the club dates three years earlier to 1893. It is claimed that this makes the club the second oldest in the country. The minute book shows an almost unbroken record to the present day, except for 1920. It was believed that the club was started by the apprentices of the Arc Works, who had been refused membership by Chelmsford Lawn Tennis Club because of their social status. After much research, Gordon Eley, in his book on the club entitled *Grove (Chelmsford) L. T. C. 100 Years of Tennis,* came to the conclusion that it was started by members of the Baddow Road Congregational church, who were residents in the Moulsham area. They initially played on a single court in Grove Road and he believes it is where Nos 12–15 Grove Road are situated today.

After the first very successful season under the Presidency of Mr J. H. White, it was obvious that the club needed an area where it could have more courts. There was a mention of moving to Goldlay Road, but in the end it moved to Vicarage Road in 1884, where it spent the next seventy-five years. For fifteen years, it was never certain whether it could use the ground the following year, as it was on an annual lease. It was a relief when the club bought the ground and in 1969, sold it and bought the present ground in Moulsham Drive where long may it thrive.

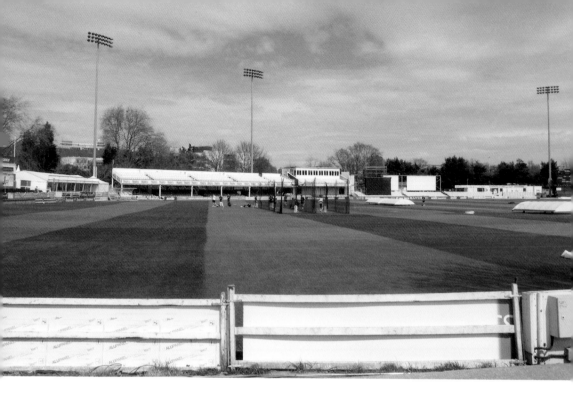

Essex County Cricket Ground

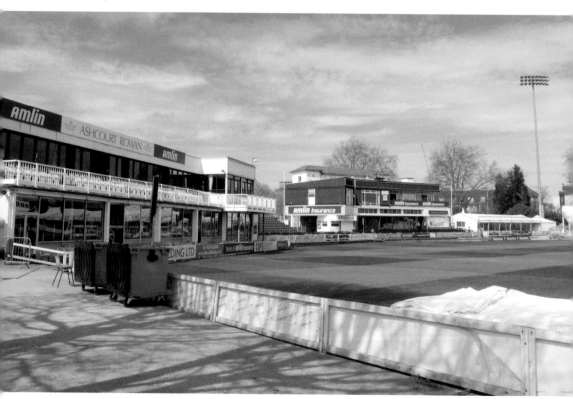

Essex County Cricket Club

The Cricket Club was founded on 14 January 1876 in Shire Hall, Brentwood, but did not become first class until 1894. In the same year, they played Leicester at Leyton ground and it was both teams' first top class match. In the following year, three clubs joined the County Championship: Essex, Leicester and Warwickshire. In this league's first match, James Burns scored the first century for Essex by scoring 114 runs and in the same innings against Warwickshire G. F. Higgins scored the second century for the club. One of Essex's highest scores was 692 against Somerset.

In 1907, they were runners up in the Championship after losing to Surrey. Between 1899 and 1932, they did not hit these heights again. Their fortunes rose during the 1933 season when they finished fourth in the league. In 1950, they came bottom, partly due to Trevor Bailey, their bowler, being called up to play for England. In 1970, overseas players were allowed and this made a vast difference. During this time, Graham Gooch joined the club and was one of England's most outstanding batsmen. During the 1984 season he scored a record 2,559 runs. Between 1979 and 1992, Essex won six County Championships. Nasser Hussain joined the club and captained England in a number of series.

In 1925, it opened its present ground in Chelmsford. The stadium holds 10,000 people and was used for two of the 1999 World Cricket Cup matches. The ground is wonderful and runs coaching for youngsters and is a very friendly club.

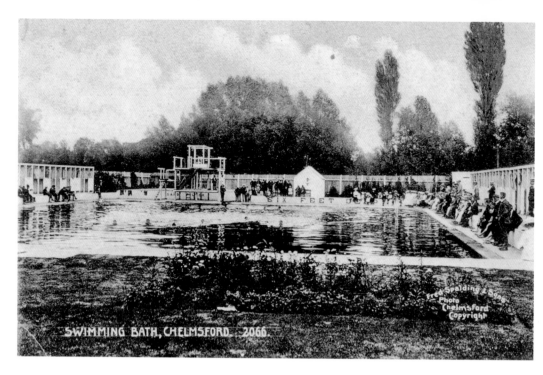

Riverside Swimming Pool, 1906, and Riverside Sports Centre, 2013
(*Copyright: Essex Record Office*)

Riverside

It took nine months to build Chelmsford Council's Swimming Pool in Waterloo Road, which was opened in 1906. It was 80 feet in length and was open to the elements. It had thirty-six dressing sheds and room for bicycles. It was the only swimming pool within an 18-mile radius. As many households did not have bathrooms, a common bathhouse was installed in 1914. In 1959, a petition was presented to the council with nearly 4,000 signatures. An indoor pool was started in 1963 and was completed in 1965, along with a slipper bath. The cost of the enterprise was £279,500. Entry to the pool was two shillings for adults and one shilling for juniors.

It was not until 1982 that the learner pool was added. The whole complex was refurbished in 1987 when the ice rink, sports hall, four squash courts, a fitness centre and a snooker hall were added. The facilities were owned by Chelmsford Council but managed by Sports Nationwide Ltd. The centre was the first in England to be managed in this way.

Riverside have a number of ice hockey teams, representing all ages and both sexes, plus instruction on skating and dancing. Over the years the sports hall has seen many dramas on election nights as the votes are counted, often going on into the early hours. The sports hall sometimes resounds with the barking of dogs at shows, compared with the tranquillity of art exhibitions.

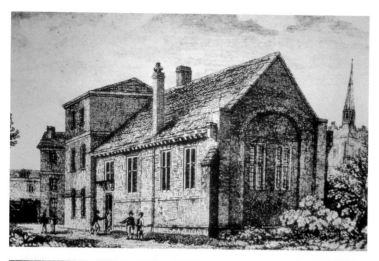

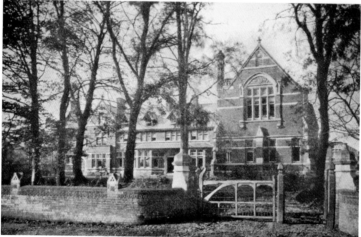

King Edward VI Grammar School
A drawing of the original King Edward VI Grammar School (KEGS) in Moulsham Street, 1627 (*above*), with the school in the 1900s and 2013 (*left and below*). (*Top image copyright: KEGS*)

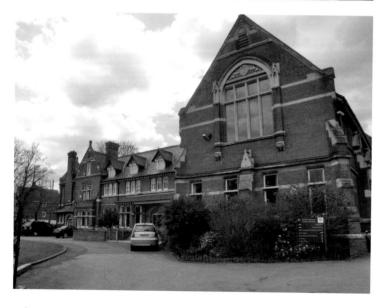

King Edward VI Grammar School

The original King Edward VI Grammar School was established by royal warrant in 1551. It was set up to educate boys of Chelmsford and Moulsham in the Anglican religion and classical languages. Until 1627, the original school was housed in the Old Friary in Moulsham Street, which was situated between Friars' Walk and New London Road and to the south of the River Can. It was financed by rents from farms in Tilbury, Hatfield Peverel, Southminster and cottages in Great Baddow. It was supervised by Sir Walter Mildmay, Sir Tyrell, and Sir William Petre and their descendants. In 1678, one of Sir William's descendants was imprisoned in the Tower of London for, allegedly, being involved in a Popish Plot.

From 1853 until 1856, the school was closed because there was a dispute over the curriculum. What suited the Tudors did not suit the Victorians!

To change the curriculum, the governing body had to approach Parliament and the cost was prohibitive. The school could not afford it. The government had a Royal Commission in 1860 and in 1869 brought in the Endowed Schools Act, which loosened the restrictions on classical education and enabled more modern subjects to be introduced. It also allowed for the Board of Governors to increase the number of pupils.

Until 1856, students had to pay for some of their education. The endowment from the farms and cottages only covered the cost of the classical and religious lessons. All other expenditure, such as heating, maintenance, books, etc., were subject to a charge. In the same year, a few of the brighter students were awarded foundation scholarships. Finance had always been difficult and gradually the farms and houses were sold off, the last one being sold in 1957. In 1944, fees were abolished completely and education was free.

Frank Rogers became Headmaster in 1885 and was a great influence on the school. In 1892, the school moved to its present site in Broomfield Road. Following the First World War, there was an increase in births; by 1930, the school became overcrowded and it was necessary to build extensions and use additional accommodation outside the school.

This excellent school runs many extra activities, such as music, drama, army cadets, a cadet band, sports club, debating sessions and the *Chelmsfordian Magazine*.

This historical school has survived through centuries, gradually increasing in stature and is a large part of Chelmsford's history.

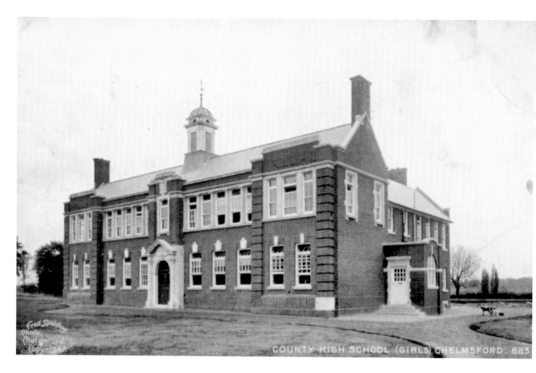

Chelmsford Girls' County High School, 1920 and 2013
(*Copyright: Essex Record Office*)

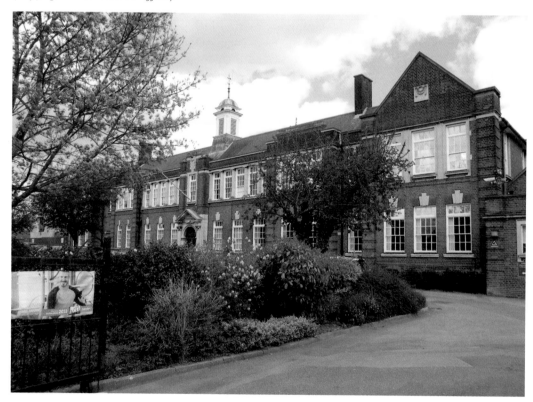

Chelmsford Girls' County High School

The Grammar School is one of the highest achieving schools in the country and regularly scores top marks for GCSE and A levels. It has approximately 880 pupils.

The school was built in 1906 and opened in 1907, with its first headmistress being Mabel Vernon-Harcourt. It started life with seventy-six pupils whose ages ranged from twelve to eighteen years but in 1915 it was decided to set up a preparatory department, admitting girls of eight. This ran for a period of thirty-two years but was closed in 1945 after the Second World War. An Old Girls Society was formed a year after the school opened and a year later the first *School Magazine* was published.

The school found that some students had to make long journeys to attend and so, in 1910, it rented No. 39 Broomfield Road to accommodate these pupils during the week. Public transport around the town slowly improved and it became apparent by 1936 that it was no longer necessary to house the students that had to travel long distances.

The school did not have long to wait for one of its girls, Winifred Picking, to gain a first at Girton College Cambridge in 1916. That was at a time when few girls went to university, let alone gain a Natural Science Degree.

During the First World War the school acted host to refugee students from Belgium; during the Zeppelin and bomber raids they did not have shelters, and pupils were given places away from windows and outside walls. Luckily, the school's precautions were never put to the test. It was different in the Second World War when the school was damaged a number of times. On the worst occasion all the windows were blown out but luckily the incident occurred during the holidays.

Over the years there have been many changes to the school buildings. The school was one of the first to have an electric bell installed to summon pupils to lessons. This was discontinued in 1999. A science block was built and male teachers were employed. In 1992, the school became a grant-maintained school, with control over its own budget.

The school's motto is '*Vitai Lampada Ferimus*' (we carry the torch of life), and I am sure that the torch will burn right through this century into the next and beyond.

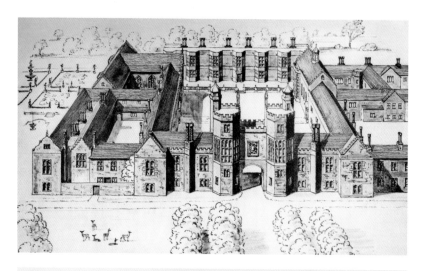

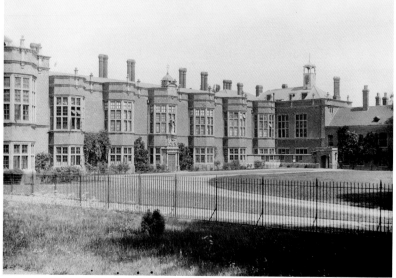

**Beaulieu/
New Hall School**
A drawing of
Beaulieu before it
became New Hall
School (*above*), and
New School Hall
in the 1900s (*left*)
and 2013 (*below*).
(*Copyright: New
Hall School*)

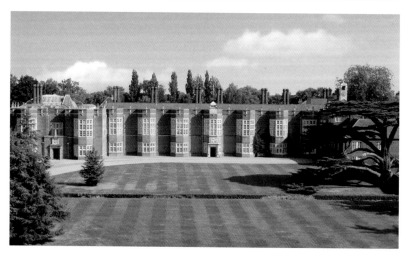

New Hall

New Hall Co-educational Independent Roman Catholic School in Boreham has a long history and is one of the outstanding buildings in the Chelmsford area. Originally, the estate on which it was built was granted to the Canons of Waltham Abbey in 1062. It changed hands a number of times but in 1516, New Hall was sold to Henry VIII and, as he often did with palaces he acquired, he built it at a cost of £17,000. He named it Beaulieu. Henry, like many previous monarchs, moved around the country and, in 1527, held court at Beaulieu. It was here that he devised a plan to cast off Katherine of Aragon and marry Anne Boleyn. Henry's daughter, Mary, by Katherine, was first barred from living in the palace where she had lived for some time but Henry later relented, making her Godmother to his son Edward, and allowing her to reside in the palace. During Henry's reign, a major fire broke out and destroyed part of the building, which had to be rebuilt.

When Elizabeth became Queen after Mary's death, she granted the estate to the 3rd Earl of Sussex, who carried out some rebuilding to the north wing. Elizabeth's coat of arms is still above the main entrance. During the English Civil War, Oliver Cromwell took possession of the estate for the sum of five shillings.

When the monarchy was restored, Charles II brought his court to the palace. There he was entertained by the Duke of Buckingham, who had taken it over following the restoration of the monarchy. By 1737, the house was in a poor state and some of it was demolished and rebuilt.

The present school was established in 1799 by nuns of the Order of the Holy Sepulchre after the French Revolution drove them out of Liege, Belgium. It only catered for girls until 2005, when it started admitting boys after 300 hundred years. Today, it has boarders of both sexes, as well as day students. It is the only independent Catholic school in the area and is one of the largest in the country. It has wonderful facilities, which include a swimming pool, national standard athletics track, football pitches, tennis courts, rugby pitches, and covers most sports.

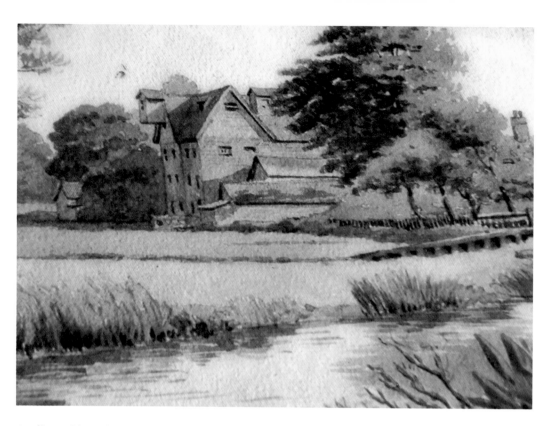

Anglia Ruskin University

Above, a painting of the Mill House near Anglia Ruskin University. Below, Anglia Ruskin's University is pictured in 2013. (*Copyright: Chelmsford City Council*)

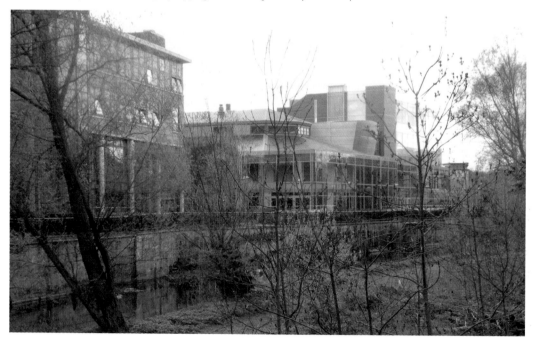

Anglia Ruskin University

Anglia Ruskin University is close to the site of Bishop's Hall Mill, Mill House, and is partially built on the site that Hoffmann's Factory occupied. Bishop's Hall Mill and Bishop's Hall was owed by the Bishop of London, who owned the Manor of Chelmsford. William was bishop between 1051 and 1075, and the mill and the Bishop's Hall were mentioned in the Domesday Book.

The mill, the Mill House and the rectory were taken over by Henry VIII during the Dissolution of the Monasteries. Thomas Mildmay, who was the auditor to Elizabeth I, purchased the Manor of Chelmsford in 1563, and it remained in the family until 1917, when it was sold. The actual mill was leased to the Marriage family in 1795.

When Hoffmann's factory was demolished in 1990, the university took over the land and built its campus.

Anne Knight, it is thought, was born in the area of Chelmsford, where part of the Anglia Ruskin University now stands. She was born in 1787 to a Quaker family, and published leaflets on women's suffrage. She also organised public meetings and wrote and distributed leaflets on anti-slavery. She formed the women's branch of the anti-slavery campaign and even had a village named after her in Jamaica. She was instrumental in setting up a campaign for equal rights for women.

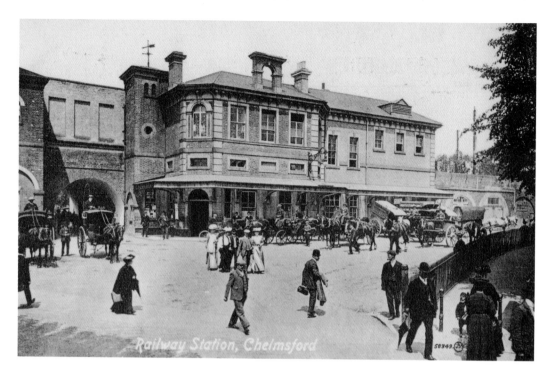

Chelmsford Railway Station, 1900 and 2013

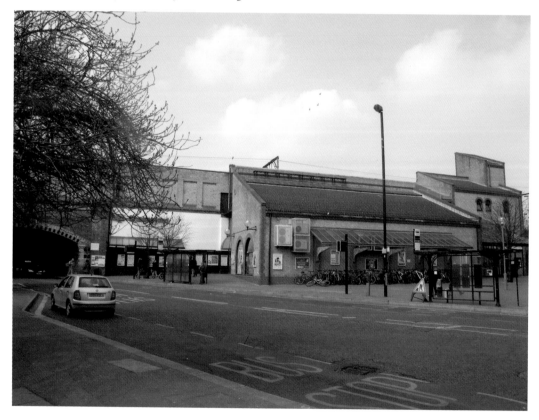

Railway Station

The coming of the railway transformed the shape of Chelmsford. In 1835, the Mildmay family, their agents and other landowners sold a corridor of land to Eastern Counties Railway, which dictated the route the railways would take to Chelmsford.

In 1842, before Chelmsford railway station could be constructed, it was necessary to build three viaducts. The longest of these is the eighteen-arched viaduct in Central Park. It is 30-feet wide and 45-feet high. One of the viaducts spans the river and the second has the station built on to the end.

The present rail station was built in 1885 and refurbished nearly 100 years later, enabling thousands of commuters to travel to London every day. There are also services to Ipswich, Clacton, Harwich and Norwich. The early railways were very popular, despite the carriages being open and passengers arriving at their destinations covered in soot; but there was a penalty to pay for the progress. The picturesque, horse-coach services, which had served the country for centuries, were much slower and less comfortable than the smoke-filled carriages, and eventually succumbed to the new mode of travelling.

As rail tracks increased over the country, Royal Mail began to use them, and stopped using the coaches, forcing many of the coaching inns to close.

At this time of change, a consortium of five businesses and a number of professional people formed the Chelmsford Company, with the aim of developing a Chelmsford where citizens could be proud of by starting to buy up the land. They proposed a new bridge across the River Can, with a New London Road, which was to have ornamental mansions and become an elegant approach to the town. The Fenton Iron Bridge connecting New London Road to the town centre was completed in 1840, but sadly forty-eight years later was swept away by the floods of 1888.

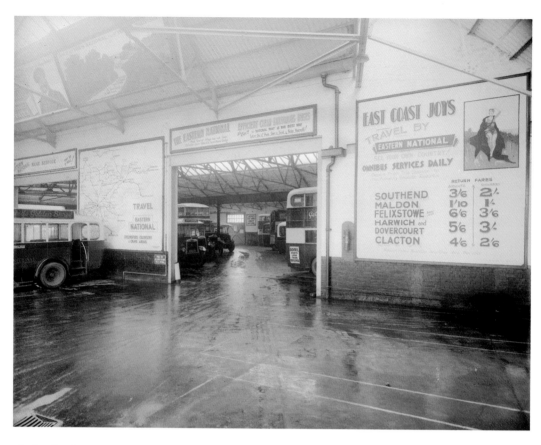

Chelmsford Bus Station, 1940 and 2013

Bus Station

A horse-drawn coach service was set up in 1730, which travelled to London each day, setting out before the sun was up at 3 a.m. In 1885, when the railway came to Chelmsford, the coach service ceased and there was no necessity to get up in the middle of the night. The roads in Chelmsford at that time were natural clay. In the summer people were expected to sweep the dusty roads in front of their premises, but most paid shovel money for somebody to do it for them. The road was regularly rolled. In winter, with rain streaming down, the roads were a quagmire.

The National Steam Car Company started to manufacture steam buses in 1903 and were seen on the Chelmsford roads. Steam buses used an oil fuel, like the steam cars. Their boilers were not like traction engines. The buses were double-deckers. The driver's cabin did not have a windscreen and the top of the bus was open to the elements. It is believed that there were bus services from Chelmsford to Great Waltham. In 1912, the Great Eastern Bus took over from the National Steam Company and operated from Chelmsford.

The bus station was opened in 1931 but, unfortunately, on 14 May 1943, a bomb dropped on the station destroying thirteen buses. A fire resulted, which spread to the houses in the area and took nearly two hours to put out.

In recent years, the old garage was demolished and a new station erected.

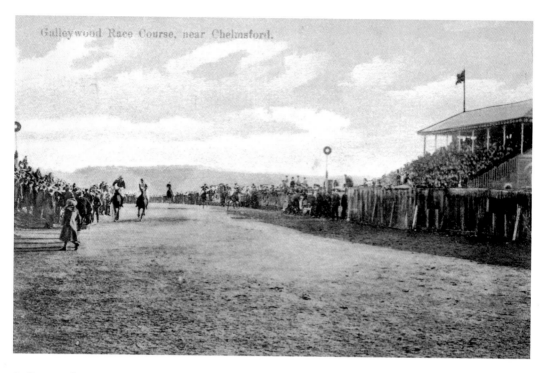

Galleywood Race Course, near Chelmsford.

Galleywood Racecourse
Galleywood Racecourse, showing the stand in 1900, and where the stand once was in 2013. (*Copyright: Chelmsford Museum*)

Galleywood Common

It is difficult to believe that Galleywood, just outside Chelmsford, once had one of the oldest racecourses in the country. Records show that racing was taking place as early as 1759, and it is believed that the 'sport of kings' was practised even earlier, possibly during the reign of Charles II (1660–80). The course was not easy as it was hilly and finished with a gallop uphill to the winning post. It is thought that it was the only racecourse where the horses went round a church. Soon after the first edition of the *Chelmsford Chronicle* was published (1764), a three- day event was announced in it. The race owners were informed that they had to register their horses at the Black Boy Inn in Chelmsford and no doubt they refreshed themselves at the same time. In 1770, King George III patronised the races and put up a purse of 100 guineas for a race he entitled 'The Queen's Plate'.

The venue was very popular and people came from all parts of the country to take part, especially after the railway siding was built on New Road adjacent to Hylands Park. This enabled the horses and racegoers to alight near the track and have a day at the races. The meetings were a great social occasion, with public breakfasts, concerts and galas. The Black Boy Inn, not wanting to miss out on this business opportunity, provided specially-priced meals. The course was alive with prizefighters, slogging it out toe to toe, and bookies shouting the odds on the dog and cockfights. There were gambling booths, games of chance and drinking tents, combined with pickpockets trying to steal the winner's money, and if they did not relieve the punters of their purse, the prostitutes did. Catastrophe struck in 1779, when during one of the racing events the grandstand caught fire and was destroyed but it did not take long for the owners build an even better one, which could accommodate 1,000 racegoers.

During the Napoleonic Wars a large star-shaped fort and earthworks were erected, with batteries of guns to prevent Napoleon's invading armies from landing in Harwich and marching on to London. Once the Battle of Waterloo had been won in 1815, and France defeated, the fortifications were demolished and racing was once again resumed with relish.

Edward VII, who was fond of all forms of gambling, attended race meetings, accompanied by his entourage. The course was not ideal, as the horses had to cross the road four times, and so, with the advent of the motor car, it fell into decline. During both World Wars, the Army took over the common and used it as a training ground, with a rifle range, anti-aircraft guns and searchlights. After the Second World War, racing never really started again and, after 186 years, it ceased.

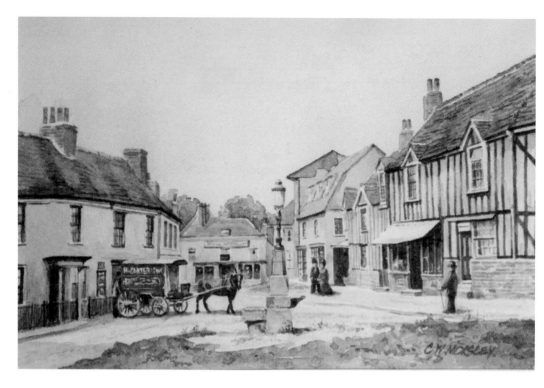

Great Baddow, 1890 and 2013

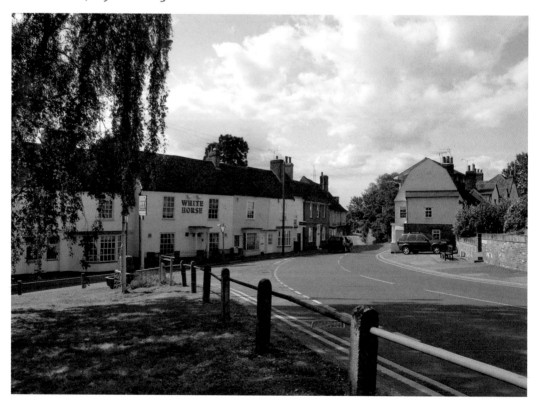

Great Baddow

There are a number of schools of thought on how this village, on the outskirts of Chelmsford, acquired its name. One theory is that it came from the De Badewe family who owned most of the land in the area during the twelfth century, but in the Domesday Book, it appears as Baduven but was later changed to Baddow. Another school of thought is that the name derives from the River Baddow, which later became known as the Chelmer. I rather like the idea of it being named after the Badewe family.

Many of the old, wonderful buildings have been demolished, like the Georgian house and grounds that were destroyed in the 1960s and replaced with the Vineyard, and the Marrable office block, which now appears to lie abandoned. Luckily, the neighbourhood has now been made into a conservation area and has thirty listed buildings that cannot be touched without permission.

The men of Essex gathered in the churchyard of St Mary of Great Baddow in 1381. Under their leader, Jack Straw, they marched on London and met the young King Richard II at Mile End, which, in those days, was just outside London. The fourteen-year-old Richard promised the rebels all they wanted. In what has been said to be a misunderstanding, the rebels' leader, Watt Tyler, was killed. The King had no intention of keeping his promise and sought out the upstarts. He came to Chelmsford in July and retracted his promises, hanging thirty local men, including Thomas Baker, on what is now Primrose Hill.

Great Baddow was one of the first places to set up a free school, established in 1736 by Jasper Jeffrey. By 1830, two other schools had been set up.

The census of 1801 showed that the population was 1,445. This rose rapidly, and by the census of 1841, it had risen to over 2,000.

The fountain opposite the old White Horse Public House was installed to commemorate Queen Victoria's Golden Jubilee. There was a lamp as well but unfortunately that was stolen.

In 1936, Marconi's relocated their Research Establishment to Baddow (now the BAE Systems Advanced Technology Centre). The great mast appeared in Baddow during the 1950s, and had been moved from an RAF station. It is now used by BAE systems.

Essex Chronicle

Unfortunately, when the *Essex Chronicle* was first printed photography had not been invented. The picture shows Marks & Spencer, which is on the site of the birthplace of the paper. As far as I know, no photographs exist of the second site the paper occupied, which was on the left of the High Street, facing towards Shire Hall.

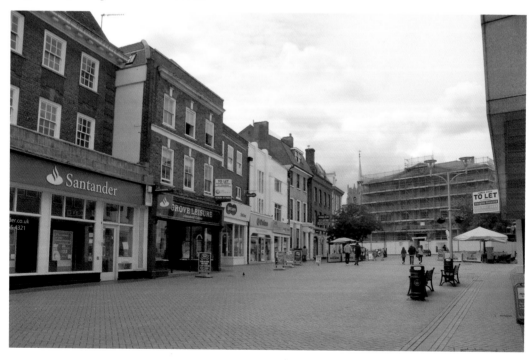

Essex Chronicle

On 10 August 1764, William Strupar set up or took over a printing works in Chelmsford High Street and launched the *Essex Chronicle*, or the *Essex Weekly Advertiser*. To emphasise the timescale, George III was King of Britain and the colonies, of which America was still one, the Boston Tea Party had not taken place, the Battle of Waterloo would not happen for another fifty-one years, and the newspaper beat *The Times* to publication by twenty-four years. At that time, Essex did not have its own paper. The works were opposite the Black Boy Inn and situated on the site that Marks & Spencer now occupies. It is understood that they later moved further down the High Street towards Shire Hall. The first issue set out the principles of the paper, one of which was that 'it would be a repository of every kind of useful knowledge'.

The newspaper started off as a sideline, as William Strupar printed other items, such as magazines, bibles, testaments, stories and plays. He also sold travelling cases, pens, quills and all sorts of stationery. In the newspaper, he set out to include all kinds of snippets that would be of interest to the public and the practice is continued today. It also included world news items, such as the movements of the Empress of Russia, and an infectious disease which had killed 3,000 people in Naples. In subsequent issues, adverts were put in, including the races at Galleywood on 21 August 1764. The paper was a success straight away, with increasing sales every week. In September of that year it reported the troubles with France and the American Colonies. The weather in those times seemed as bad as today, with damage being reported to the quays in London, right up the Thames' mouth. In 1765, the printers changed the name of the paper to the *Chelmsford and Colchester Chronicle* or the *Essex Weekly Advertiser*.

In 1963, colour was introduced in the paper, which was a first for the whole of mid-Essex. The paper has moved a number of times over the years but is currently at Westway, Chelmsford, and after 249 years, I am glad to say, it is thriving.

The Paper, 2013

Acknowledgements

I wish to express my thanks to the following people, without whose help and patience, this book would never have been written. Although I have made every effort to be as accurate as possible, any mistakes are mine and I apologise in advance for them.

First, I must thank my good friend, Sylvia Kent, who has helped and loaned me many of the photographs in the book; the staff of Chelmsford Museum, especially Dr Mark Curteis PhD AMA FRNS, for his invaluable help and for allowing me to use the museum's photographs; Nick Wickenden; John Green, Press Officer of Anglia Ruskin University; Emma Powell of New Hall School; Becky, Mick Barry and the team at the Essex Police Museum (which is well worth a visit); Malcolm Wallace, who allowed me to use an extract on Coleman and Morton from his book *Chelmsford Star – A Co-operative History*; Tony Creek of Essex Fire Brigade; Andrew Coburn Secretary of Chelmsford and District Trade Union Council; Stuart Axe, who allowed me to use photographs from his collection; Mr and Mrs Wilson, who run an excellent café shop in the mill (the food is great and they were so helpful); Mr Tuckwell, author, who allowed me to use pictures from his book entitled *That Honourable and Gentleman like House: A History of King Edward VI Grammar School*; Lindsey Thompson, KEGS Public Relations Officer; Emma Powell of New Hall School, who supplied information and photographs of the school; Peter Marriage, of Marriages Flour, who was so helpful, allowing me to use old pictures of the Marriage's Mills; Anne Cowper-Coles, volunteer Curator of Chelmsford Cathedral; Ian Lucking, for the information on Broomfield Hospital; Sue Robinson of Grove (Chelmsford) Lawn Tennis Club; Michael Foley, author of many books, for his valuable advice; Ceri Lowen, Manager of Hylands House, who supplied photographs of the old house; Yvonne Lawrence, Learning Services Manager, for information on the city; Liz Meer and her sister, of Grey & Sons Brewers, who supplied pictures of the brewery; Lauretta Lamont for her information on Britvic; Mrs Hilton of Chelmsford Girls' County High School; Lindsey Thompson, Peter Higginbotham, Colin Brown and the staff of the Essex Record Office, for their help and understanding; Janet West, Marketing Officer Chelmsford City Council; Paul Dent-Jones of the *Essex Chronicle*; Garry Chidley of Chelmsford Cricket Club; my researcher Olive Norfolk; Joe Pettican at Amberley Publishing; and by no means least, Joan, my wife, for her enormous help, patience and understanding during writing my book.

STEPHEN P. NUNN

MALDON & HEYBRIDGE

THROUGH TIME

Maldon & Heybridge Through Time

Stephen P. Nunn

This fascinating selection of photographs traces some of the many
ways in which Maldon & Heybridge have changed and developed
over the last century.

978 1 84868 074 6
96 pages, full colour